KU-112-434

WeCreate
A CELEBRATION OF SCOTLAND'S CREATIVE TALENT

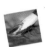
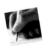
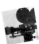

THE LIST GUIDES

CREATIVE SCOT LAND
ALBA | CHRUTHACHAIL

Editors: Mark Fisher & Laura Ennor

Designer: Lucy Munro

Production manager: Simon Armin

Production assistant:
Hannah Graham

Contributors: Kelly Apter, Jen
Bowden, Niki Boyle, Brian Donaldson,
Rosalie Doubal, Cara Ellison, Miles
Fielder, Eddie Harrison, Talitha
Kotzé, Carol Main, Susan Mansfield,
Ally McCrae, Milo McLaughlin,
Nicola Meighan, Anna Millar, Henry
Northmore, David Pollock, Jonathan
Pryce, Charlotte Runcie, Claire
Sawers, Yasmin Sulaiman, Gail Tolley,
Devon Walshe.

Researchers: Phoebe Cook, Melissa
Steel, Rhona Taylor, Sally Webber.

Director: Simon Dessain

Publisher: Robin Hodge

This publication has been produced
by *The List* which is responsible for
the selection of those included and
for all editorial content. *The List* would
like to thank Creative Scotland for
its support. The project managers
within Creative Scotland were Bernard
Regan and Harriet Baker.

ALBA | CHRUTHACHAIL

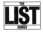

Published by The List Ltd
Head Office:
14 High Street
Edinburgh EH1 1TE
Tel: 0131 550 3050
www.list.co.uk

ISSN: 978-0-9557513-6-3

Printed by Scotprint, Haddington

DIGITAL DIRECTORY

To accompany this printed
publication, *The List* is compiling
a digital directory of creative
organisations across Scotland. It
includes major institutions together
with many smaller companies that
are actively involved in the creative
process. Each entry has a concise
description of the work they do along
with contact details.

**The directory listings are
browseable at list.co.uk/wecreate**

WELCOME TO
WeCreate

The publication of Alasdair Gray's novel *Lanark* in 1981 marked the start of a period which has seen a remarkable flowering of creative talent in Scotland. A succession of writers, artists, musicians, actors, filmmakers, designers and others have produced work that has met with critical acclaim and commercial success both here and across the world.

Alongside the many well-known names who have built high profile international reputations (such as JK Rowling, Tilda Swinton, Ewan McGregor) and those who have won major prizes (including James Kelman, Douglas Gordon, Ian Rankin, James MacMillan, Don Paterson), there are many other individuals and organisations who have been creating work of real originality and quality.

It would be an impossible task to pull together the complete range of all the creative talent in or from Scotland today. But this slim publication, released to mark the Year of Creative Scotland 2012, attempts to showcase as wide a selection as possible. The limitations mean that there has not been space to include or even mention everyone and, inevitably, some of the brightest and best may be missing from these pages. But it does seek to demonstrate the breadth of creativity, from prominent artists at the height of their powers to the up-and-coming generation ready to surprise us.

To help cover a wider group, a directory of creative organisations and institutions across Scotland is online at list.co.uk/wecreate. Throughout the year, The List publishes detailed listings of all the arts events taking place across Scotland and the rest of the UK. And remember, there is more where this came from every month in *The List*.

Admiral Fallow

HELLO
Foreword

Everywhere you look, Scotland is buzzing with imagination, technical excellence and creative life, says Andrew Dixon, chief executive of Creative Scotland

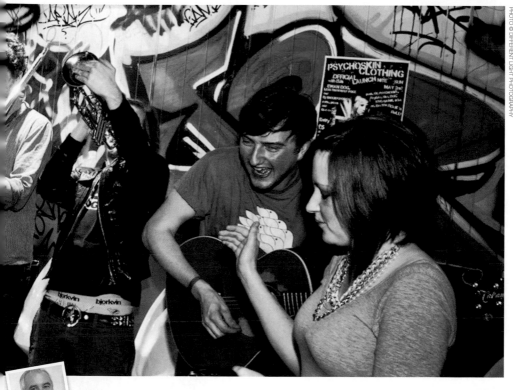

We create! Two words to inspire, excite and celebrate. Scotland is rich in creative talent, from the islands to the Borders, and we have some of the brightest talents showcased here.

Right across the country, there are places and spaces to hear and see the kind of acts – be it traditional musicians or the next big Scottish sound – that bring audiences from around the world to share the magic.

Glasgow is a centre for excellence in the visual arts and artists who've trained here, or made the city their home, are represented in the collections of the world's finest contemporary galleries. Designers, too, add to Scotland's reputation for stylish living – from Timorous Beasties' look-twice wallpaper, to the environmentally sound homeware of Blue Marmalade. And it's not just inside that Scotland's designers excel – architects are remaking and remodelling 'the public realm' in ways that reference both our outstanding natural assets and our industrial past.

Fashion's catwalks are flourishing with the work of new Scottish designers, including many of the world's top luxury brands, who know quality, diversity and innovation when they see it.

Scotland's deft touch with the written word – either in the imaginations of our writers or the canniness of our publishers in spotting good stories, well told – has seen our literary reputation bloom. Whether it's tartan noir or poetry slam, Scotland holds its writers dear and relishes sharing stories both comic and dark.

In the technically pre-historic days of the mid-90s, a small company in Dundee was in midst of developing a gaming revolution. Fifteen years and 114 million units later, *Grand Theft Auto* remains a landmark, credited with opening the doors to lifelike animation techniques and immersive action play. Dundee is still a developers' crucible, producing apps, games and pushing the boundaries between the digital and analogue worlds.

Did I mention film? Wonderful locations, amazing actors, skilled crew? Don't take my word for it – see on screen, in *Cloud Atlas*, *Under the Skin*, or *World War Z*.

Creative Scotland is proud to support The List in producing a publication which roll-calls the breadth of creativity from these shores. We work hard to support this talent, making over 1200 awards in 2011/12 – from supporting a raft of individual artists, to making long-term commitments to agencies and organisations who foster and nurture the output they produce.

We create? You bet, and how.

home & away

Some of Scotland's artists making a splash around the world

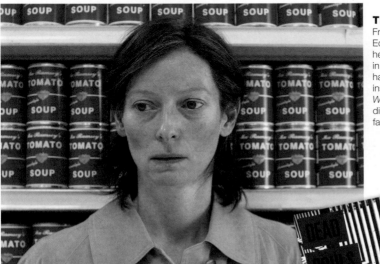

TILDA SWINTON

From her early starring roles at Edinburgh's Traverse Theatre to her Oscar-winning performance in *Michael Clayton*, Swinton has stayed true to her artistic instincts. She's pictured here in *We Need to Talk About Kevin*, directed by Lynne Ramsay, a favourite at Cannes.

ANDY GOLDSWORTHY

From his home in Dumfriesshire, Goldsworthy sustains an international career, responding to the landscapes of anywhere from rural Haute Provence to Edinburgh's Jupiter Artland, creating site-specific sculptures of beguiling beauty. His Leaf Spiral (pictured) was included in an exhibition at Linlithgow Burgh Halls.

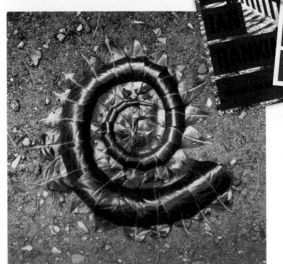

IAN RANKIN

Played by John Hannah and Ken Stott, Inspector Rebus has kept the Edinburgh author busy on nearly 20 novels. More recently, Rankin has introduced us to police complaints investigator Michael Fox, as well as collaborating with the late Jackie Leven, Aidan Moffat and Saint Jude's Infirmary.

JAMES MCAVOY

The Port Glasgow actor has won critical acclaim in Kevin Macdonald's *The Last King of Scotland*, cornered the family market as Mr Tumnus in *The Chronicles of Narnia* and wowed the blockbuster crowd as Charles Xavier in *X-Men First Class*. He's pictured here in 2007's *Atonement*.

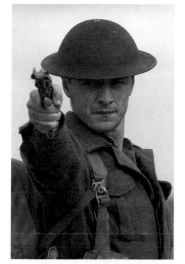

DOUGLAS GORDON

The Turner Prize-winning Glasgow artist who took *Psycho*, Alfred Hitchcock's most famous film, and slowed it down to last 24 hours (pictured) has gone on to make a film about footballer Zinedine Zidane and come up with the visuals for a Rufus Wainwright tour.

DAVID SHRIGLEY

Having injected a healthy dose of fun into the art world, Shrigley most recently spread the love into the theatre with *Pass the Spoon*, 'a sort of opera about food' set to the music of David Fennessy and staged by Edinburgh's Magnetic North.

JAMES MACMILLAN

In Scottish Opera's production of *Clemency*, staged in the 2012 Edinburgh International Festival, the Ayrshire-born composer confirmed his place at the forefront of 21st-century classical composition, building on the reputation of works such as *The Confession of Isobel Gowdie* and his adaptation of Jo Clifford's *Ines de Castro*.

KEVIN BRIDGES

Having started out as a teenager at the Stand Comedy Club in Glasgow, Bridges reached the final of the *So You Think You're Funny?* competition on the 2008 Edinburgh Fringe before being given a big Michael McIntyre-shaped leg up to national stardom.

7

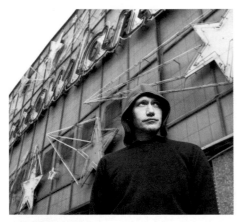

NICOLA BENEDETTI

The North Ayrshire child prodigy, who was named BBC Young Musician of the Year in 2004, was one of the highlights of the 2012 Last Night of the Proms where she stormed her way though Bruch's *Violin Concerto No 1 in G minor*.

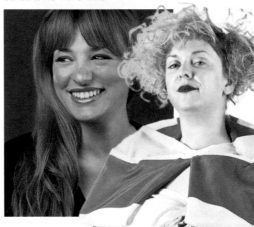

MICHAEL CLARK

The Aberdeen-born bad boy of dance is as happy setting moves to the music of The Fall as he is to Stravinsky. He recently made waves in Glasgow, where his *Barrowlands Project* featured 40 local dancers and the music of Pulp and Scritti Politti.

JK ROWLING

Where would Edinburgh's cafés be without being able to claim JK Rowling as a customer while she wrote the early drafts of *Harry Potter*? The creator of the world's most famous boy wizard is now courting a grown-up audience with *The Casual Vacancy*.

RICHARD WRIGHT

A graduate of both the Edinburgh and Glasgow schools of art, the Turner Prize-winning Wright specialises in exquisitely realised geometric designs painted directly onto the walls of galleries and places he finds architecturally interesting.

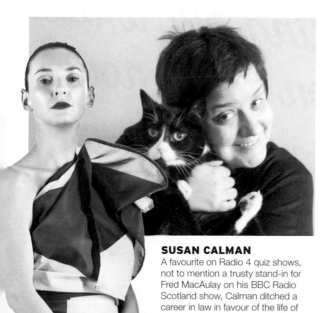

GREGORY BURKE

The playwright thought he'd scored a big hit with *Gagarin Way* on the 2001 Edinburgh Fringe, but that was nothing compared with the acclaim received by *Black Watch* in 2006. John Tiffany's production for the National Theatre of Scotland is on the road to this day.

SUSAN CALMAN

A favourite on Radio 4 quiz shows, not to mention a trusty stand-in for Fred MacAulay on his BBC Radio Scotland show, Calman ditched a career in law in favour of the life of a stand-up. It was a trade-off that made the world a merrier place.

JOHN BYRNE

Having established himself as an artist, a playwright and a set designer, the former Paisley slab boy extended his range to children's books in 2011 with his large-format, lavishly illustrated *Donald & Benoit*.

LIZ LOCHHEAD

The poet who replaced the late Edwin Morgan as Scotland's Makar is as well known for her theatre work – such as *Mary Queen of Scots Got Her Head Chopped Off* (pictured in the NTS production) – as she is for collections such as *True Confessions and New Clichés*.

DAVID TENNANT

The favourite Scottish stage actor won a 2005 CATS award for his Jimmy Porter in *Look Back in Anger* at Edinburgh's Royal Lyceum just as his *Doctor Who* career was about to make him a household name. He's pictured here in the BBC's *Single Father*.

Want to find out what's going on right now?

UP TO 30,000 UK WIDE EVENTS LISTINGS
OVER 300,000 PERFORMANCES
LIST.CO.UK - WE'VE GOT IT COVERED

Performance

Pictured here in *Enquirer* by the NTS, Billy Boyd is part of a generation of actors, playwrights, comedians, dancers and other stars of the stage whose reputation extends beyond their native land . . .

TAKE 10
up-and-coming theatre makers

Mark Fisher rounds up some of the brightest – and most multitalented – young stage talents

JOE DOUGLAS After graduating in 2006 with a degree in theatre directing, Douglas got an early break when he became a trainee director in residence with the National Theatre of Scotland. His production of Dennis Kelly's children's show *Our Teacher's a Troll* for the NTS was raucous, funny and pretty scary to boot. Most recently, he stepped out from the wings to star in the Fringe First-winning *Educating Ronnie* for Stirling's MacRobert, telling the true story of his fraught relationship with the Ugandan boy he befriended during a gap year.

ROB DRUMMOND You can't fault Drummond for ambition. The Glasgow writer, performer, director and magician trained as a professional wrestler to prepare for *Rob Drummond: Wresting*, he took on the greatest story ever told in a version of *The Passion* staged in Glasgow's George Square and he asked an audience member to fire a gun at him every night in the acclaimed *Bullet Catch*. In comparison, inventing a story every night in the CATS award-winning kids show *Mr Write* must have been a doddle.

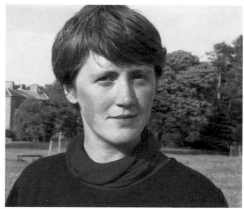

KIERAN HURLEY The writer and performer turned heads with his monologue *Hitch*, the true story of an ill-prepared journey to the earthquake-hit town of L'Aquila to protest at a meeting of the G8 countries. Nominated for a CATS award in 2010, it was an early sign of an emerging generation of politically engaged theatremakers. The promise was fulfilled in 2012 with *BEATS*, a DJ-accompanied evocation of the illegal rave scene of 1994 when loved-up dancers fell foul of the buttoned-up forces of authority. It duly won the CATS' best new play gong.

EILIDH MACASKILL Every day in 2007, MacAskill headed out with her ukulele to perform wherever she was made welcome. It was an exercise she called *Eilidh's Daily Ukulele Ceilidh*, a title certified by top scientists as the best name for anything ever. As a lynchpin of Glasgow's Fish & Game, MacAskill is typically found in a not-quite-definable realm of performance art. For the Arches Behaviour festival she created three events in praise of the bicycle. Different again was *Alma Mater*, an installation in which the spectator entered a child's bedroom while carrying an iPad.

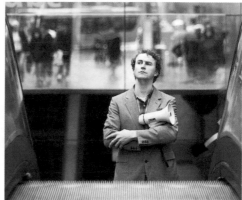

MOLLY TAYLOR As the star of her own *Love Letters to the Public Transport System*, Taylor broke everyone's heart with her stories of travelling by train and bus from Liverpool to London to Glasgow at significant emotional moments. The National Theatre of Scotland production was revived for a run on the 2012 Edinburgh Fringe, where she also found time to appear in a verbatim theatre piece by Look Left Look Right. Taylor, who was part of the NTS's Bank of Scotland Emerge programme, also appeared in the first production of Gary McNair's *Born to Run* (see right).

GARY MCNAIR Another writer-performer-director with an appetite for political engagement, McNair worked as a company associate at the National Theatre of Scotland after graduating from the former RSAMD and now specialises in one-person shows on thought-provoking topics. In *Crunch*, he considered the nature of money, and in *Count Me In*, he picked apart the supposedly democratic voting system. On the 2012 Edinburgh Fringe, he made Shauna Macdonald run on a treadmill for over an hour as she starred in *Born to Run*, his play about athletic endurance and need to escape.

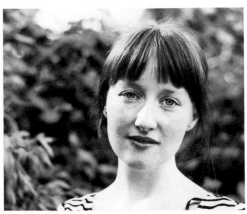

LYNDA RADLEY Like many writers of her generation, the Cork-born and Glasgow-based Radley is often to be found performing in her own plays. She's been spotted in *The Art of Swimming*, a monologue about her obsession with a cross-Channel swimmer, and in *Birds and Other Things I am Afraid of . . .*, a coming-of-age tale performed in a shed built on the altar of Glasgow's Lansdowne Parish Church. Only in 2011 did she extend her range to other actors when Dominic Hill staged her freak-show themed *Futureproof* for the Traverse and Dundee Rep.

STEF SMITH A writer-on-attachment for the National Theatre of Scotland, the Aberfoyle-born Smith is celebrated as the writer of *Roadkill*, Cora Bissett's Olivier Award-winning site-specific drama about sex-trafficking. That harrowing play typifies her interest in politics and the importance of shining a light on hidden stories. She also works as a director, staging her own plays including 2012's *The Silence of Bees*, a meditation on the declining bee population, performed in a Sauchiehall Street soap shop.

ROSS MACKAY A specialist in object theatre for grown-ups as well as children, MacKay is a driving force in the Edinburgh-based Tortoise in a Nutshell. Established in 2007, the company got people talking with 2010's *The Last Miner*, a moving show about an old man sifting through the memories of the dilapidated mine where he once worked. MacKay and the team went on to considerable success on the 2012 Edinburgh Fringe with *Grit*, a vision of children in war zones, conjured up through imaginative use of lots of cardboard and an overhead projector.

JENNA WATT Following her free-flowing creative instincts, the Inverness-born Watt is variously a director, a performer and a live artist. She was assistant director on the National Theatre of Scotland's *27* and is creative administrator for Lung Ha's, but she is becoming best known for her solo pieces, not least the 2012 Fringe First-winning *Flâneurs*, a subtle polemic in favour of the right to roam our city streets without fear. To give you an idea of her range, she was previously best known for a performance in which she smashed apples with a baseball bat.

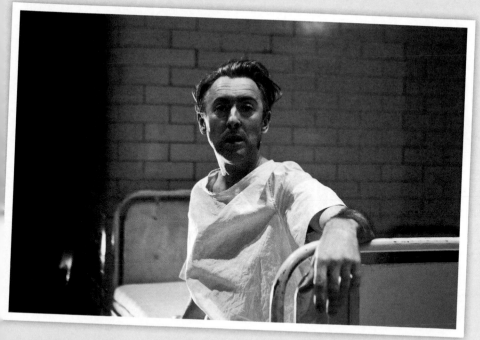

FACTFILE:
NATIONAL THEATRE OF SCOTLAND

• **What is it?** Launched in 2006, the NTS aims to put all theatrical activity in Scotland, from community drama to mainstage classics, on a national footing.

• **What's the big deal?** Billing itself as a 'theatre without walls', the NTS has no building of its own and operates within the existing infrastructure of Scottish theatre. Although it does put on some productions entirely under its own name, it is just as likely to collaborate with other companies. This enables it to celebrate the talents already at large across the country and prevents it from becoming the kind of central monolith that other national theatres have become. It also allows it to champion all forms of theatre, from site-specific plays to Christmas shows, without being tied down to one type of theatre. It's an innovative structure that has since been borrowed by National Theatre Wales.

• **What's its claim to fame?** By a tremendous stroke of fortune, the NTS had its biggest hit in its very first year. Gregory Burke's *Black Watch*, a large-scale show relating the experience of Fife squaddies in Iraq, was the hit of the 2006 Edinburgh Fringe and is still on tour internationally today. Other triumphs include a one-man *Macbeth* starring Alan Cumming (pictured), a spooky version of *A Christmas Carol* and David Greig's pub-based comedy-chiller *The Strange Undoing of Prudencia Hart*.

• **Who's in charge?** Vicky Featherstone is the founder artistic director, building the company from a staff of one to the powerhouse it is today. She is leaving to take on London's Royal Court at the start of 2013, so there is much speculation about her successor.

• **Who else is about?** Featherstone's number two is John Tiffany, the director of *Black Watch* and *Macbeth*. Other key players include Simon Sharkey, associate director of Learn, who is responsible for all the big community projects, and Graham McLaren, associate director, whose productions include *A Christmas Carol* and *Men Should Weep*. nationaltheatrescotland.com

pointe taken

Kelly Apter finds artistic director Christopher Hampson ushering in a new era for the award-winning Scottish Ballet

Astunning home in Glasgow's Tramway, a new set of international dancers and a re-vitalised company – that's what Ashley Page left behind when he bid farewell to Scottish Ballet after ten years as artistic director. His time at the company brought about great change, and a great many new works, but in August 2012, it was time for somebody else to take over the reins.

Enter Christopher Hampson, the man charged with taking Scottish Ballet into the future. If his ballet pedigree is anything to go by, we're in safe hands. Trained at the Royal Ballet School, before performing for several years with English National Ballet,

Hampson retired from dancing in 1999 to concentrate on choreography.

Since then, his work has appeared in repertoires in New Zealand, the USA and Europe. Scottish Ballet, however, is giving Hampson his first opportunity to run a company – not a challenge you take on lightly. So what is it about Scotland's national ballet troupe that appealed to him?

'One of the privileges I had in my previous career as a freelance choreographer working around the world, is I often see the UK from an outside perspective,' says Hampson. 'And Scottish Ballet, right from way back when, has always had quite a unique voice on the UK dance scene. It's forward-thinking and seeks collaboration in its creative process and, because of the broad choreographic vocabulary used here, they're a very dynamic group of dancers.'

In recent years, the technical standard of Scottish Ballet's dancers has risen

markedly, leading to tours of the USA and China, four appearances at the Edinburgh International Festival, and winning the 2008 Critics' Circle Award for Outstanding Classical Repertoire. Additionally, principal dancer Sophie Martin picked up the Outstanding Female Award, and Ashley Page the Award for Outstanding Achievement, at the 2011 Critics' Circle Awards.

Its most recent production, *A Streetcar Named Desire*, deservedly garnered a glut of five-star reviews. As far as Hampson is concerned, however, Scottish Ballet may be in fine form – but it could always be better.

'I don't think any company ever reaches its peak,' he says. 'There is always room for improvement. And that's what's wonderful here at Scottish Ballet – people are really up for the ride, for pushing through to the next level.'

He adds: 'My hope is that I can intensify and build on those qualities, broaden the repertoire considerably, and continue to raise the technical

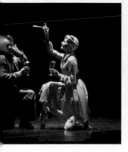

'People are really up for the ride, for pushing through to the next level'

standard of the dancing.'

Guest choreographers are a regular occurrence at Scottish Ballet, each bringing a new way of working for the dancers to adapt to. Speak to any of those choreographers, however, and they'll all tell you what a special experience they had with the company. Hampson knows why.

'One thing that differentiates the dancers at Scottish Ballet with other companies I've worked with, is there's a real intelligence and autonomy to their approach,' he says.

'I spent a couple of weeks with them during the creation of *A Streetcar Named Desire*, which was a very new way of producing dance, working with a theatre director. And I was really enthused to see that the dancers were 100 per cent committed to the project, to working on their characterisation, and taking on board the director's input. I don't think there are many companies out there that could field that diverse a range of inputs.'

TAKE FIVE
SCOTTISH DANCE COMPANIES

SCOTTISH DANCE THEATRE
Our national contemporary dance company consistently produces diverse work that challenges and entertains. Look out for changes with new artistic director Fleur Darkin.
scottishdancetheatre.com

SMALLPETITKLEIN
Led by choreographer Thomas Small, this Dundee-based company creates emotionally strong works such as the 9/11-inspired *Falling Man*.
smallpetitklein.com

PLAN B
Best known for superb dance theatre piece, *A Wee Home From Home*, Plan B are back with new work *More Skye Than We Need* in 2013.
www.planbcreative.org

DAVID HUGHES DANCE
From his days with Rambert and Matthew Bourne, through his solo ventures, and now running his own company, David Hughes has always been one to watch.
davidhughesdance.co.uk

JANIS CLAXTON DANCE
Having turned the concept of dance on its head by hanging out in Edinburgh Zoo's primate enclosure, Claxton's company visits museums and galleries across Scotland with new work *Chaos and Contingency* in 2013.
janisclaxton.com

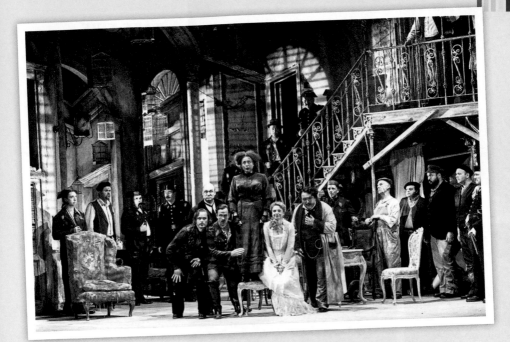

FACTFILE:
SCOTTISH OPERA

• **What is it?** Founded in 1962 by Sir Alexander Gibson, Scotland's national opera company celebrates its 50th anniversary in 2012/13. Not without its dramas off-stage as well as on-stage over the years, Scottish Opera is one of five national performing companies that are funded directly by the Scottish Government.

• **Where is it?** Its home is the Theatre Royal in Glasgow, where a £4.8m redevelopment project is underway with completion scheduled for 2014, in time for the Commonwealth Games. The company performs at the Edinburgh International Festival as well as presenting its main season in Glasgow, Edinburgh, Aberdeen and Inverness. Touring productions reach over 50 theatres, village halls and community centres throughout the country. Its education and outreach programme involves thousands of primary school children and offers many adult learning events and taster sessions.

• **But opera's not cheap . . .** New Zealander Alex Reedijk joined the company as general director in 2006, a time of one of Scottish Opera's many encounters with financial uncertainty. The company's orchestra controversially changed working practice from full-time to part-time in 2010. Similarly, the full-time chorus was cut back in 2004 and is now entirely comprised of freelance singers.

• **Who's in charge?** There have been only four music directors in the company's 50 years, the present incumbent being Francesco Corti, who has been particularly successful in bringing Italian opera to Scottish audiences since his appointment in 2007. Richard Armstrong is notable as a past music director for the acclaimed *Ring Cycle*, which opened at the 2003 Edinburgh Festival, and the world premiere of James MacMillan's *Inés De Castro*.

• **Other hits?** One of Scottish Opera's most successful recent achievements is the *Five: 15* operas initiative, a five-year research and development project, supported by Made in Scotland, to give opportunity to an up-and-coming generation of composers, librettists and directors.

TAKE 10
theatre spaces

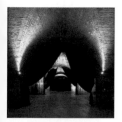

THE ARCHES Subterranean vaults beneath Glasgow's Central Station where you'll catch a new generation of theatremakers, live artists and musicians following in the tracks of Nic Green, Kieran Hurley and Rob Drummond.
thearches.co.uk

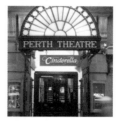

PERTH THEATRE Artistic director Rachel O'Riordan is consolidating Perth's reputation for classics old and new, as well as welcoming favourite companies such as Mull Theatre and Magnetic North.
horsecross.co.uk

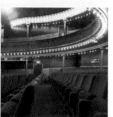

CITIZENS Artistic director Dominic Hill mines the classical repertoire and presents it alongside Glasgow-centred drama on the attractive proscenium-arch stage. Expect names of the calibre of Neve McIntosh, David Hayman and Kath Howden. **citz.co.uk**

PITLOCHRY FESTIVAL THEATRE With a season that now extends across most of the year, artistic director John Durnin fields a large cast in a daily changing repertoire of popular 20th-century comedy and drama.
pitlochry.org.uk

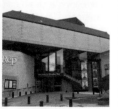

DUNDEE REP Using Scotland's only permanent ensemble of actors, Jemima Levick and Philip Howard (both taking over in 2013) present larger-scale classics, musicals and new plays, plus visiting companies.
dundeereptheatre.co.uk

ROYAL LYCEUM Director Mark Thomson stages classics, translations and new work in Edinburgh's grand rep, with actors of the calibre of Maureen Beattie and writers as good as Liz Lochhead, Peter Arnott, DC Jackson and Jo Clifford.
lyceum.org.uk

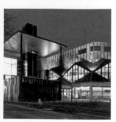

EDEN COURT THEATRE A draw for arts lovers in the Highlands and islands, this attractive complex has two theatres, two cinemas and additional studio spaces to accommodate its packed line-up of visting companies.
eden-court.co.uk

TRAVERSE Scotland's home of new writing and one of Edinburgh's cultural hotspots is led by Orla O'Loughlin who is building on a legacy of plays by David Greig, David Harrower, Chris Hannan, Zinnie Harris, Rona Munro and Douglas Maxwell. **traverse.co.uk**

ORAN MOR The Glasgow pub is home to A Play, a Pie and a Pint, David MacLennan's phenomenally successful lunchtime series, showcasing David Harrower, David Greig, Gerda Stevenson, Zinnie Harris, Gregory Burke et al.
oran-mor.co.uk

TRON Artistic director Andy Arnold has re-established this friendly theatre as a hub for Glasgow's acting community, programming a mix of in-house productions and visits from the likes of Random Accomplice, Stellar Quines and Vox Motus.
tron.co.uk

youth opportunities

Mark Fisher casts an eye over the many organisations putting on shows for and by young people

One of Scottish theatre's great success stories is the number of exceptional children's companies to have emerged over the last 20 years. Catherine Wheels, Frozen Charlotte, Licketyspit, the Puppet Lab, Starcatchers, TAG, Visible Fictions and Wee Stories, as well as artists such as Andy Cannon, Andy Manley and Shona Reppe, have repeatedly delighted young audiences with work that is not only the equal of adult theatre but frequently better. The international success of *White* by Catherine Wheels, *The Curious Scrapbook of Josephine Bean* by Shona Reppe and *Jason and the Argonauts* by Visible Fictions suggests children abroad think so too.

Behind much of this achievement is Imaginate (imaginate.org.uk) which, as well as presenting a festival of children's theatre every spring in Edinburgh, is a year-round supporter of home-grown companies. By bringing some of the best theatre and dance in the world to Scotland, Tony Reekie's programmes have raised the bar for artists working for children here.

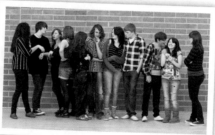

The desire for young people to join in means Scotland also has a profusion of youth theatres, many of which are pushing far beyond the old certainties of the end-of-term school play. Foremost among these is Junction 25 (junction-25.com), based at Glasgow's Tramway, which accomplishes the rare feat of creating shows by young people that grown-ups (and not just the parents) want to see.

Artistic directors Jess Thorpe and Tashi Gore free up their teenage cast to speak for themselves, while presenting their ideas in a striking, beautiful and artful way. Productions such as the Herald Angel Award-winning *I Hope My Heart Goes First* (pictured, right), about first love, and *Anoesis*, about the challenges of conforming to school rules, have earned the kind of rave reviews even an adult company would die for.

Over in Edinburgh, Strange Town (strangetown.org.uk – pictured below) also does a good job of putting young people's voices on the stage. Productions are devised in conjunction with writers – names such as Sam Siggs, Tim Primrose and Duncan Kidd – who themselves have not long graduated from the company's ranks. It's an approach that keeps the work fresh, lively and tuned-in.

The ever-expanding Strange Town empire now includes a Young Company for 18–25s, a talent agency and a programme of after-school drama clubs. Companies doing similar work include Firefly (firefly-arts.co.uk), based in Livingston, and Toonspeak (toonspeak.co.uk), in the Royston area of Glasgow. Many professional companies, such as Eden Court, Inverness (eden-court.co.uk) and the Royal Lyceum, Edinburgh (lyceum.org.uk), run youth theatres, and many of these feed into Scottish Youth Theatre (www.scottishyouththeatre.org), a national performing arts company that holds an annual three-city summer festival culminating in a public production or two. Graduates include Karen Gillan, Gerard Butler and KT Tunstall. SYT also runs weekly drama sessions for 3–25 year olds in Glasgow, Edinburgh and Aberdeen.

Keeping an eye over the whole sector is Promote YT (promoteyt.co.uk), which represents over 80 youth theatres, and holds the annual National Festival of Youth Theatre, the largest of its kind in the UK. It also programmes Skill Up, an annual training event for youth theatre workers.

Many professional theatre companies run educational outreach programmes to complement their productions. The National Theatre of Scotland does all this and more through its Learn department. Here, director Simon Sharkey works on the principle that 'You can't be creative without learning something; you can't learn something without being creative.' Aimed at all ages, his work ranges from staging post-show talks and backstage tours to providing resource packs for teachers and putting on community shows.

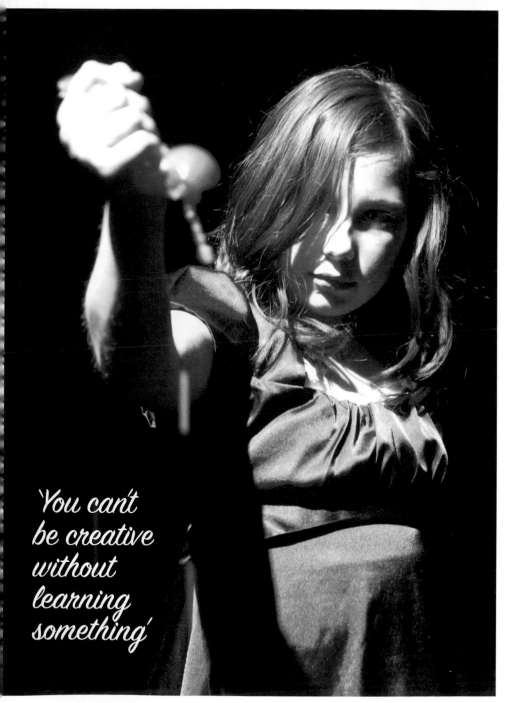

'You can't
be creative
without
learning
something'

TAKE 10
collaborations

PASS THE SPOON It sounded like an unlikely dish, with ingredients including off-beat artist David Shrigley (who wrote the libreto), modernist composer David Fennessy and Magnetic North director Nicholas Bone working with the Red Note Ensemble, but when it emerged from the oven, this 'sort of opera about cookery' turned out to be funny, surreal and very tasty. Audiences and critics sent their compliments to the chef. **magneticnorth.org.uk**

SCARECROWS AND LIGHTHOUSES Take filmmaker David Mackenzie, sculptor Martin Boyce and saxophonist Raymond MacDonald, give them a Vital Spark award, tell them to drop their artistic preconceptions and send them out into the world together. The result: an ongoing series of unclassifiable installations at Glasgow's Tramway. Gallery, cinema or concert hall? Yes to all of the above. **scarecrowsandlighthouses.com**

WHATEVER GETS YOU THROUGH THE NIGHT An after-hours reverie at Glasgow's Arches that pooled the talents of actor/director Cora Bissett, dramaturg David Greig and the band Swimmer One, plus contributions from Ricky Ross, Annie Griffin and many others, resulting in a hybrid that was neither theatre nor gig, but was loved by anyone who'd stayed up past their bedtime. Oh, and there was also a movie. **throughthenight.net**

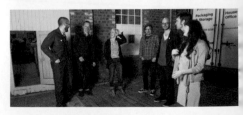

BIDING TIME Glasgow's A Band Called Quinn earned a theatrical pedigree when they provided the live soundtrack to Vanishing Point's dystopian version of *The Beggar's Opera* at Edinburgh's Royal Lyceum in 2009. In October 2012, members of the band hooked up with Grid Iron director Ben Harrison at Glasgow's Arches for a blend of storytelling, music and film by Uisdean Murray – plus silent-disco technology – based on a play by Pippa Bailey. **abandcalledquinn.com**

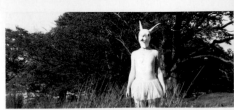

THE SHOOGLE PROJECT Was it a ceilidh? Was it a modern dance performance? Did you watch? Did you join in? Yes, yes, yes and yes, as Frank McConnell's Highlands-based dance company Plan B hooked up with the foot-stomping Shooglenifty (no mean masher of genres themselves) for a show where the lines between participation and performance were well and truly blurred. **planbcreative.org**

Pigeon-holes are so square. These days, artists are jumping the genre barrier. Mark Fisher singles out some of the most imaginative

THE MAKING OF US Graham Eatough, best known as the artistic director of the now defunct Suspect Culture, and Graham Fagen, visual artist, have collaborated on a series of shows that sit at the meeting place between performance and installation. The most recent, at Glasgow's Tramway and part of Glasgow International, featured a film crew putting together a movie while the audience raced from set to set piecing together the story. **tramway.org**

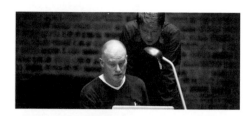

FIVE:15 The finished results were recognisably opera, but many of the collaborators were a surprise. Scottish Opera commissioned 15-minute librettos from names previously unfamiliar to the genre, including novelists Louise Welsh, Zoe Strachan, Bernard MacLaverty and Ian Rankin, teaming them up with composers including John Harris, Lyle Cresswell and Craig Armstrong. The result was 15 short operas produced between 2008 and 2010. **scottishopera.org.uk**

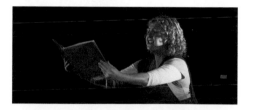

GOD HELP THE GIRL Still in production, this Glasgow-set musical feature film is bringing the talents of Belle and Sebastian's Stuart Murdoch to the big screen as he re-imagines his 60s-infused 2009 album of the same name in cinematic terms. As well as drawing money from Channel 4's Alpha Fund, the film has been crowd-funded through Kickstarter by the many fans who can't wait to see it happen. **godhelpthegirl.com**

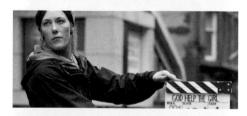

SPEED OF LIGHT With its after-hours rambles into the Scottish countryside, NVA has brought on board all manner of musicians, technicians and performers. For the 2012 Edinburgh International Festival, artistic director Angus Farquhar headed to Arthur's Seat with *Shaun of the Dead* choreographer Litza Bixler, lighting designer Phil Supple, designer James Johnson and the sound specialists of the Resonance Radio Orchestra, not to mention thousands of hill runners. **nva.org.uk**

NEU! REEKIE! All artforms are welcome in Michael Pedersen and Kevin Williamson's self-styled creative circus, a monthly Edinburgh cabaret that encourages avant-garde spoken word, animation, music and short-film fusions. There's an associated record label, extracurricular visits to London, Ayr, Glasgow and Manchester, and a roster of performers from Alasdair Gray and Liz Lochhead to Stevie Jackson of Belle and Sebastian. **neureekie.tumblr.com**

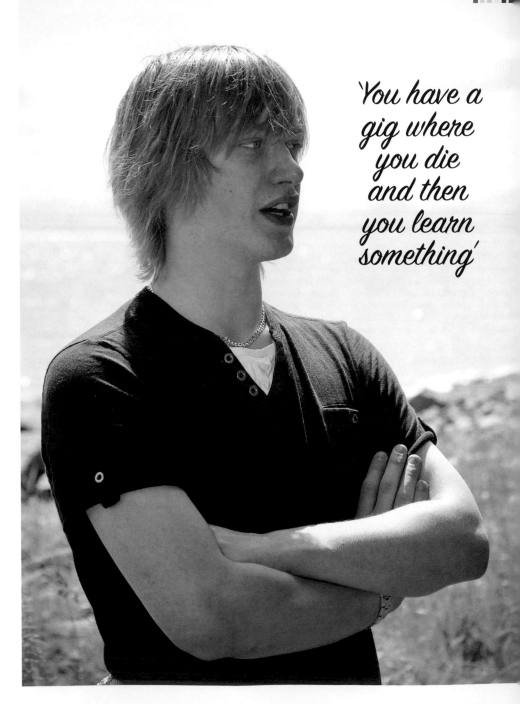

'You have a
gig where
you die
and then
you learn
something'

family entertainment

At 22, Daniel Sloss already has a wealth of stand-up experience behind him. Here, he talks about comedy mums, nurturing venues and Frankie Boyle

The Scottish comedy scene is now way bigger from when I started and there are more open spots than ever before. In Scotland you have the Stand Comedy Clubs, which are easily in the top five comedy clubs in the world. The waiting list to do open spots there was about a month back then, whereas now it's almost a year. But they are so supportive and make sure the rota is being fair and the ones that they see with potential aren't left waiting longer.

But that's the big one, it's like getting to the semi-finals: you're nearly there now. If you want to do something different, you have to make sure it works because there are so many other new comics that you'll be pushed to the side so there's more pressure.

I always refer to JoJo Sutherland as my comedy mum. She MCed my second ever gig and really took me under her wing. She really looked after me and gave me advice; same with Susan Calman who made sure I was comfortable and relaxed, even though I was annoying in the way only a new comic can be: you have seven five-minute gigs under your belt that went well and wondering where your TV show is. But then you have a gig where you die and then you learn something.

A lot of the regular MCs at the Stand are very nurturing people like Billy Kirkwood and Keir McAllister, and the Stand staff turn that place into a home for you. The Scottish circuit is good because it is a bit more nurturing and people are pleased when someone else does well.

Those early days with Frankie Boyle was a work experience thing; he taught me the ways of writing and then allowed me to write for him. At no point was there any day where he was sitting down thinking, 'I can't go on, I haven't got Daniel Sloss's material through.' A lot of the early articles made out that I was somehow his protégé that he was feeding off, but for me it was a learning experience and he was just being this genuinely supportive, lovely man trying to give a young cocky kid a leg up in the world; he was such a big boost at the start of my career.

Kevin Bridges was such an inspiration as well, because he started at 16 and was always willing to say, 'This is what you do,' and even when he became 'Kevin Bridges', he was the same guy, it never went to his head. I now write with Tom Stade who lives nearby, and he helped make me unafraid of new material. He really opened me up to different ways of writing and helped me deliver it in such a way that, even if it was about tennis, it was as though I had genuine opinions about tennis. (As told to Brian Donaldson)

Daniel Sloss Live is released on 2entertain DVD.

You can't really talk about stand-up comedy in Scotland without mentioning the **Stand Comedy Club** (thestand.co.uk), a venue that attracts top touring comics, household names trying out new material and is a platform for young comics to get their big break with Red Raw.

In Edinburgh, the **Shack** (theshackedinburgh.co.uk) runs weekend gigs and a Gong Show, the **Beehive Inn** (beehivecomedyclub.com) has its own newbie night and Beatnik Comedy resides at the **Tron** (facebook.com/troncomedy).

In Glasgow, **Jongleurs** (jongleurs.com) runs a club at the Glasshouse, and there are talent nights for new comics and circuit stand-ups with Pop-Up Comedy at the **Halt Bar** (pop-upcomedy.co.uk), Comedy @ the State at the **State Bar** (comedyatthestate.co.uk) and there's a new material night at **Vespbar** (vespbar.com).

Outside of the big two, **Just Laugh** (justlaugh.co.uk) runs regular nights in Perth, Inverness and Dundee and arts venues and pubs across the country will house comedians from time to time. (Brian Donaldson)

so you want to be a . . .

Standard theatre and comedy offerings not enough for you? Looking to take inspiration from the more niche corners of the performing arts scene? Read on!

CABARET ARTISTE

The neo-burlesque scene has gone mainstream thanks in no small part to the efforts of Club Noir (clubnoir.co.uk), which runs events all over the country from its base at the O2 Arena in Glasgow. Claiming a place in Guinness World Records for being the biggest burlesque club in the world, it programmes DJs, divas, bands, films, fetish acts, comedians and variety stars.

CIRCUS PERFORMER

With an interest in street theatre and circus skills, Conflux (conflux.co.uk) offers support, training and international residencies to anyone who wants to get physical. Based at Glasgow's Arches, it runs the biennial Surge festival, which takes place in theatres and on the streets, and keeps in touch with performers on the internet via the Scottish Street & Circus Arts Network (SSCAN).

LIVE ARTIST

The recent demise of New Territories and the associated National Review of Live Art may have closed down one career path, but performance artists don't play by the rules and continue to pop up where you least expect them. That may or may not be at the Arches and the Tramway in Glasgow, at various art school hang-outs or at Summerhall, the watch-this-space newcomer in Edinburgh.

MAGICIAN

Since its launch in 2010, the Edinburgh International Magic Festival (magicfest.co.uk) has doubled its ticket sales and will be back pulling rabbits out of hats 28 June–5 July 2013. Its programme draws from far and wide, attracting performers from the Ukraine, Germany and France as well as closer to home. In addition to close-up magic, large-scale illusions and street entertainment, the festival runs masterclasses and a magic school.

PUPPETEER

The organisation with its fingers on the strings is Puppet Animation Scotland (puppetanimation.org) which, as well as running the Puppet Animation Festival (puppetanimationfestival.org), the UK's largest performing arts event for children, also programmes Manipulate (manipulatefestival.org), an annual festival of object theatre for adults, starting to expand outwards from its base at Edinburgh's Traverse. (Mark Fisher)

LISTEN UP

Music

Turning out top ten hits for herself and others, Aberdeenshire's Emeli Sandé has a talent of Olympian proportions. She's just the latest in a long line of Scottish musicians who believe in going for gold . . .

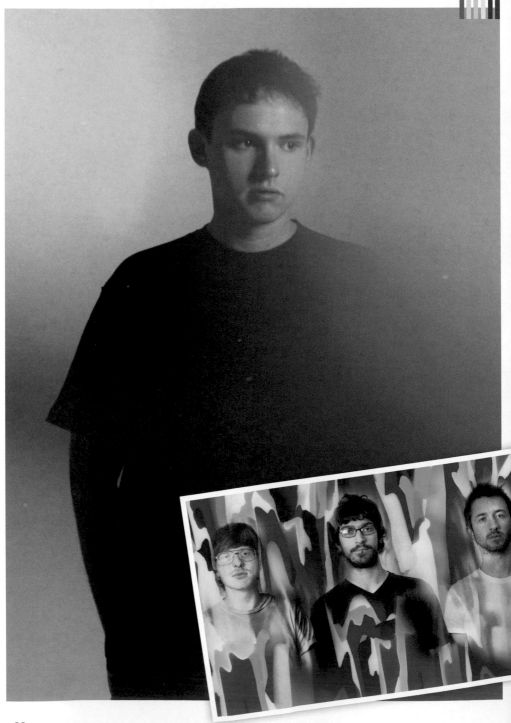

record highs

With Hudson Mohawke and Rustie now well-respected names on the global electronica circuit, David Pollock tracks the ongoing evolution of the multi-faceted scene that produced them

Glaswegian music producers Hudson Mohawke (pictured, left) and Rustie have been key figures in the British electronic music landscape for the last couple of years. The former (real name Ross Birchard) has ended up in the studio with Kanye West and Chris Brown, while the latter (aka Russell Whyte) won 2012's *Guardian* First Album Award for *Glass Swords* and had his track 'After Light' used by Adidas during the London Olympics.

The pair are now signed to seminal electronic label Warp, but two of the most respected young labels in Scotland have their roots in the highly regarded club nights from which they emerged. One of these, LuckyMe, actually started as a hip hop night in 2002. The other, Numbers, began the following year and went on to define the sound of the city in the last half-decade, placing it at the forefront of a new generation of bass music creators.

Richard Chater founded the Numbers collective with Calum Morton (who DJs as Spencer), Jack Revill (Jackmaster), Neil Norton, Adam Rogers (Goodhand) and Rob Mordue. Although 'HudMo' and Rustie were never officially members, their early reputations were integrally bound to the club night.

'The important thing is, we're all still good friends with one another,' says Chater, whose label has its origins in Rubadub, the Glasgow record store where most of the Numbers team still work.

He says Numbers' local profile rose after it booked big-name guests such as Autechre and Ghostface Killah. This was possible once they'd graduated to the renowned Sub Club from smaller venues Adlib and the Brunswick Hotel basement.

They stregthened the brand further by merging the members' hobby labels, including Wireblock, Stuffrecords and Dress 2 Sweat, into the NMBRS imprint. 'Our first release was Deadboy's 'If U Want Me' in 2010,' he says. 'Since then, we've released records by artists like Mosca ['Done Me Wrong/Bax'] and Jamie xx.'

The latter's 'Far Nearer' was The xx member's first solo release.

The LuckyMe collective credit Numbers for being a big influence and a great help in showing them how to run a label. Formed in Glasgow, they are currently widely spread: day-to-day heads Dominic Flannigan and Martin Flyn are based in London and Edinburgh respectively, while creative consultants Ross 'Hudson Mohawke' Birchard and Mike Slott are in London and New York.

They have released work by Machinedrum, The Blessings and American Men (pictured, below left), and recently joined with Warp to co-release the album by Hudson Mohawke and Lunice as TNGHT. Their showcase events include parties during the Edinburgh Fringe and at Sonar in Barcelona, and they also maintain a second specialism as a design agency.

'At the time it seemed like there was no one else doing this in Scotland,' says Flannigan, 'but when we started, we realised everything was there for us to turn this into a full-time job. It was an exciting time for electronic music in Glasgow.'

Like the Numbers boys, they were regulars at Optimo, the seminal Sunday-night party at the Sub Club run by Twitch and Wilkes (Chater also cites Paisley's Club 69 as one of the influences on Numbers).

'I was at art school at the time, so design's always been a part of what we do,' says Flannigan. 'All our sleeves have been a collaborative effort. The fact we advertised our design background led to us doing art direction and website work for other labels and fashion brands.'

He suggests that social networking and online interaction have become key to running a 21st-century label. 'Day to day, we write a lot of emails,' he says. 'The majority of this business is communication, whether that's overseeing the production of the records, having collective input on how to market them or staying in touch with our artists.'

Location also makes a big difference, says Chater: 'Glasgow's got a good infrastructure. Rubadub handles distribution for Numbers and LuckyMe, and there's a lot for people who love music including some very good club nights. Not just average clubs - great ones.'

thisisluckyme.com, nmbrs.net

scottish albums
of the 21st century

TAKE 10

PRIMAL SCREAM
XTRMNTR
(2000, Creation Records)
If the Scream's 1991 classic *Screamdelica* was a night out clubbing, *XTRMNTR* was the acid-fried come down. An overtly political, aggressive rock assault packed with searing electronics, paranoia and guitar fuzz. Sadly it was also the last LP ever issued by iconic British indie label Creation.

FRANZ FERDINAND
Franz Ferdinand
(2004, Domino)
For one tantalising moment, these Glasgow art school new wavers looked like they would take over the world. Their Mercury Prize-winning debut looked to have pretty much sealed the deal with 'Take Me Out's majestic schizo-pop, the melodically marching 'Matinee' and the delightfully ambiguous 'Michael'.

BIFFY CLYRO
Only Revolutions
(2009, 14th Floor Records)
If *Puzzle* was the moment Biffy went 'mainstream', this was the Ayrshire trio honing their skills, juxtaposing soaring melody with their cacophonous rock roots. Still delivering a visceral gut punch, they added a collision of strings, electronics and thundering riffs. Instantly accessible yet satisfyingly complex.

CONQUERING ANIMAL SOUND
Kammerspiel
(2011, Gizeh)
Beautifully celestial spooky pop from Scotland, *Kammerspiel* went on to win the duo of Anneke Kampman and Jamie Scott a nomination for the inaugural Scottish Album of the Year award. Lacing together tape hiss, ethereal vocals, bleeps, glocks and toys on tracks like 'Bear' and 'Giant', it was a heavenly debut.

MOGWAI
Mr Beast
(2006, PIAS)
After a couple of merely excellent releases, *Mr Beast* comes along and proves that the 'Gwai do textured and tough, rich and rugged, beauty and ballsy like few others. While 'Glasgow Mega-Snake' bashes tendons in two, 'Friend of the Night' will snap your little heart asunder.

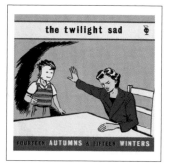

THE TWILIGHT SAD
Fourteen Autumns and Fifteen Winters
(2007, Fat Cat)
They may not yet have acquired the fame of label/touring mates Frightened Rabbit, but the Sad's debut outstrips the Selkirk band's work for rawness and sheer epic melancholy. Their swelling, troubling mix of creepy lyrics, white noise and dark melodies cemented their spot on the Scot-rock Walk of Fame, if such a thing existed.

ERRORS
It's Not Something But It Is Like Whatever
(2008, Rock Action)
A danceable, satisfying follow-up to the mathy brilliance of their first EP, 'How Clean is Your Acid House'. The electro-rock debut from the Glasgow boys showed the rest of the world just why Mogwai fell for them and took them under their label wing.

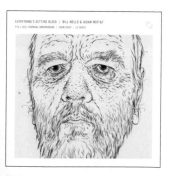

AIDAN MOFFAT & BILL WELLS
Everything's Getting Older
(2011, Chemikal Underground)
Put together the bawdy, bittersweet storytelling of Mr Aidan Moffat with the lush jazz arrangements of multi-instrumentalist Bill Wells and what do you get? Some very excellent mournful, filthy and playful laments – and winner of the first Scottish Album of the Year award in 2012.

REMEMBER REMEMBER
The Quickening
(2011, Rock Action)
A bit krautrock, a bit ambient, sort of cinematic, sometimes whispery and twinkling, other times driving and insistent . . . behold the wide-ranging LP from six-piece Remember Remember, fronted by the multi-talented, sometime Harmonia and Fuck Buttons support act, Graeme Ronald.

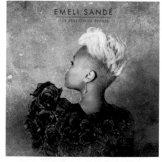

EMELI SANDÉ
Our Version of Events
(2012, Virgin Records)
The bequiffed Aberdeenshire singer-songwriter was the breakthrough act of 2012. After writing hits for Tinie Tempah and Cheryl Cole, she released this album of her own smart, acoustic guitar and piano-led songs, big beat-driven soul ballads and stirring anthems – all sharing that soaring, powerful, sophisticated voice.

TAKE 10
new scottish music acts

GAV PRENTICE
Gav's debut solo album *The Invisible Hand* came out in late 2012 on Instinctive Racoon. Heartfelt songs aplenty delivered with a Frank Turner kind of passion and lyrics that it's hard not to relate to. Raise a glass and shout along.
facebook.com/gavprentice

CARNIVORES
Paisley's Carnivores give a crap about the world and saving it from average rock music. Socially conscious lyrics coupled with the odd 90s pop culture reference are spat out to thunderous QOTSA-sized riffs and some infectious hooks akin to Twin Atlantic.
facebook.com/carnivoresuk

HOSTAGE
Quality EP releases on Black Butter have caught the attention of big-time DJs like Mista Jam and Annie Mac. He's demon live and his remixes are of the highest order, check his mix of Nina Nesbitt's 'Boy'. He doesn't just toy with beats – he mutilates them.
facebook.com/alanhostage

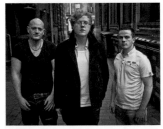

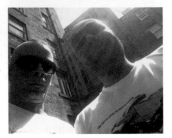

SIOBHAN WILSON
Wilson, originally from the Highlands, now in London via France, has a voice with a range that reaches from dark, haunting undertones to some delicate, impossibly high moments – that alone deserves some love.
facebook.com/ siobhanwilsonmusic

IMMACULATE EMOTION ENGINES
The roster of net label Black Lantern Music is an education in all things left-field – their latest offering is the free download album from IEE. Deep, dark, sometimes disturbing tracks await you, with some scathing bars and intense beats.
blacklanternmusic.com

CRUSADES
Relatively new to the Scottish hardcore music scene are Crusades, their ferocious intensity is captured perfectly in the debut *Golden Throats* EP. Their live show . . . well, the first one was cut short as the guitarist bludgeoned himself due to excessive riffing and had to hit the hospital. Standard.
crusades.bandcamp.com

Ally McCrae, DJ, BBC Radio 1 presenter and co-creator of Detour (purveyors of fine Scottish podcasts and live music jaunts), picks ten of the Scottish music scene's most exciting prospects

WHERE TO SEE AND HEAR ROCK AND POP IN SCOTLAND

KONCHIS

Just check this dude's Soundcloud – it's filled with some of the most innovative hip hop beat making around. Swirling, squelching sounds can take your mind miles away in a matter of seconds. He's leading the next wave of Scottish producers.
soundcloud.com/konchis

CHURCHES

Electro pop doesn't come more direct and catchy than this band formed by Aereogramme and the Unwinding Hours' Iain Cook, The Twilight Sad's Martin Docherty and Blue Sky Archives' Lauren Mayberry. Live, it's as shimmering and engaging as on record.
soundcloud.com/churchestheband

'Though she be but little, she is fierce!' Shakespeare once said. The same is true for Scotland's music scene. Its live venues range from anthem-rocking stadii (Murrayfield and Hampden have hosted Madonna, Take That and Bruce Springsteen in the past) right down to divey little bars where you can check out art school bands who only formed a few weeks earlier.

Those seeking local, grassroots talent should keep an eye on Electric Circus or the Wee Red Bar in Edinburgh, or King Tut's, Bloc and Nice'n'Sleazy in Glasgow, while the best of the touring bands tend to stop in at the Queen's Hall, Usher Hall, Sneaky Pete's or Liquid Room in the east and the Arches, Barrowland, Stereo, the Berkeley Suite and O2 ABC in the west. As well as players such as DF, Regular and PCL, it's worth keeping an eye on excellent local promoters Cry Parrot, Braw Gigs, Detour and From A Stolen Sea, who've put on gigs in churches, parks, warehouses and even toilet blocks. (Claire Sawers)

WE ARE THE PHYSICS

The Physics have really stepped things up a gear this summer with two dynamite new singles and talk of an album coming soon. Live they are a compelling watch – it is utterly bonkers rock music with stupidly tight fight-pop riffs and dance moves like the Scissor Sisters at a Danananananakroyd reunion show.
wearethephysics.com

HECTOR BIZERK

Watching people stand up and take notice of Hector Bizerk's brand of rap was one of my favourite things about 2012. We got them to T in the Park on the BBC Introducing stage and in session on my Radio 1 show – a show that the Mercury-tipped indie kings Alt-J heard, subsequently falling for the bold, totally unique sound summed up by their fairly descriptive motto: 'Rap. Drums. Yes.'
soundcloud.com/hector-bizerk

feast on folk

Scotland's contemporary folk music is vital, dynamic and genre-defying. It re-animates mythic realms via acid-washed folk-rock (Trembling Bells); applies Gaelic customs to avant-garde art forms (Hanna Tuulikki, Muscles of Joy); celebrates punk and DIY pop doctrines (James Yorkston, Wounded Knee, King Creosote and Pictish Trail's Fence Collective); mines and advances oral traditions (Alasdair Roberts) – and it resonates with mainstream promise (Rachel Sermanni), sublime protest poetry (Karine Polwart) and live exhilaration (Lau). Here, three exceptional modern artists tell Nicola Meighan about the Scottish folk and art that most inspired them

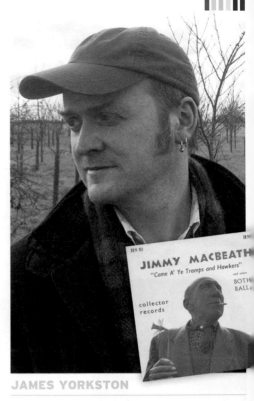

JAMES YORKSTON

'Jimmy MacBeath and John Strachan were Bothy singers, born in the 19th century in north east Scotland. They were unrelated, unpaired – never sang together as far as I know. MacBeath was itinerant, a tramp, while Strachan was a laird on a farm, comparatively well-to-do, and they bought with them vast repertoires of song. Macbeath's reflected his sometimes uncouth or bawdy audience, while Strachan learned songs from his mother and farmworkers and sang them in a plummier voice.

I love their use of Doric and the beggar's cant, full of beautifully descriptive language, but they also had the ability to convey a long song themselves – no bells and whistles, guitars and drums. The singing of traditional song was mostly always performed that way of course, but their styles are natural and un-staged – there's no heightening of pitch or warbling of voice – it's just them, sing-speaking their songs. As a guy who can't sing in the *X-Factor* sense, I take great relief and confidence in the gravelly mutterings of this pair and others like them.'

James Yorkston's latest album, *I Was a Cat From a Book*, is out now. You can hear Jimmy MacBeath and John Strachan on *Whaur the Pig Gaed on the Spree*, compiled by 'bastard heir' Alasdair Roberts.

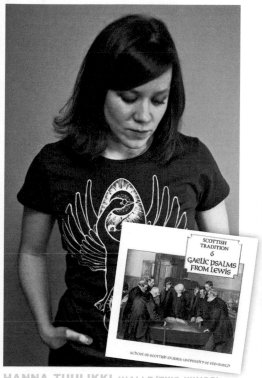

HANNA TUULIKKI (NALLE/TWO WINGS)

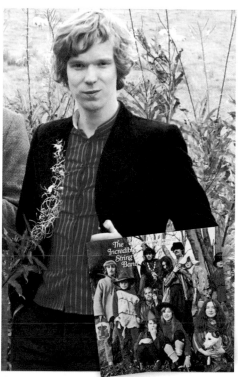

ALEX NEILSON (TREMBLING BELLS)

'When I first listened to Gaelic psalm singing I was struck by the powerful unearthly sound created by a layering of voices that rise and fall like waves on the shore. Sung unaccompanied and led by a precentor, the magic happens when the congregation sings. Each individual joins in with their own spontaneous response to the melody, singing the same phrase but at different speeds and with varying degrees of ornamentation. The result is a complex monophony that is fiercely passionate yet tenderly plaintive.

The ideas of spontaneous response and layering have influenced how I write compositions and the way I sing. Gaelic psalm singing led me to dig more deeply into Gaelic vocal traditions, especially those where land, sea and birds are evoked through song. As a direct result, I'm now working on a large-scale project, *Air falbh leis na h-eòin | Away with the Birds*, exploring the mimesis of birds in Gaelic song and influenced by the structure of psalm singing.'

Two Wings' album, *Love's Spring*, is out now. For other projects see hannatuulikki.org. Hear Gaelic psalm singing on *The Scottish Tradition Vol 6: Gaelic Psalms from Lewis*.

'As the Incredible String Band, Mike Heron and Robin Williamson gave the hippy generation some of their most emblematic anthems. In tunes like 'Maya' or 'A Very Cellular Song', with their epic perspectives, pantheistic lyrics and synthesis of psychedelia with the folk musics of the world, ISB achieved in a couple of ditties what most bands struggle to explain over entire careers. The breadth of their appeal is beguiling, with residents of the House of the Holy as differing as Robert Plant and Rowan Williams professing a long-term love affair with the band.

The pair seemed like perfect foils: Robin the self-styled seer, reporting back from a dream of pre-Christian Britain; Mike with a drug-abetted child's-eye-view of the world. Equal parts charity-shop prophets, omnivorous appropriators of musical form and intrepid cosmonauts of inner-space, their slight differences in approach only served to strengthen their musical alchemy.

Their re-evaluation of Britain as a place of myth and arcane imagination was a great inspiration to me. This is music rooted deep in the black, black earth and its only limit is the blue, blue sky.'

Trembling Bells' album with Bonnie 'Prince' Billy, *The Marble Downs*, is out now.

a classical beauty

Ten examples of excellence in Scotland's orchestral, choral and chamber music

ST MAGNUS CATHEDRAL
ORKNEY

The centrepiece venue for the annual midsummer St Magnus Festival, which fills the long summer nights with classical music of the highest order. Work has been commissioned from a long list of composers including James MacMillan, Gordon McPherson, founder Sir Peter Maxwell Davies and director Alasdair Nicolson.

WOODEND BARN
BANCHORY, ABERDEENSHIRE

Banchory might not be the obvious home for a cutting-edge festival of contemporary music, but Woodend Barn's eight-year-old Sound draws international attention. The 2012 festival provided a forum for the fruits of the Three Cities Project, linking artists in Aberdeen, Bergen and St Petersburg.

PERTH CONCERT HALL
PERTH

Opened in 2005, Perth Concert Hall is the newest in Scotland. It hosts classical music events including Schubertiad, a modern-day version of the 19th-century get-togethers celebrating the life and work of the great composer.

STRATHPEFFER PAVILION
HIGHLANDS

A restored spa pavilion dating from the Victorian era when the Duchess of Sutherland decided to model Strathpeffer as a spa resort more like Harrogate or Baden Baden than its Highland neighbours. Now the venue is a regular stop for Scottish Opera on its frequent tours of the Highlands and islands.

ORKNEY

ABERDEEN

INVERNESS

LEWIS

SKYE

EAST NEUK FESTIVAL
FIFE

This summer festival offers world-class music in unexpected locations in the pretty villages of the East Neuk. International and local musicians have played in atmospheric churches, beautiful old buildings and even a disused aircraft shelter.

USHER HALL
EDINBURGH

This beaux arts concert hall is regularly visited by the Royal Scottish National Orchestra and Scottish Chamber Orchestra, and, as a central venue of the Edinburgh International Festival, it hosts globally renowned ensembles. It is the opening setting of Alexander McCall Smith's *The Sunday Philosophy Club*.

RAPLOCH STIRLING

Following Venezuela's incredible classical music/social change *El Sistema* project, Raploch is Sistema Scotland's first orchestral centre. Four years after the project began, local children opened the London 2012 festival alongside Gustavo Dudamel. See feature, page 34.

ROYAL CONSERVATOIRE OF SCOTLAND
GLASGOW

Scotland's conservatoire (formerly RSAMD) has turned out generations of theatre, music and dance stars. Among those in the classical music world who cut their teeth there are composers Patrick Doyle and David Fennessy, violinist Ani Batikian, trumpeter Mark O'Keefe, soprano Lisa Milne and the late conductor and founder of Scottish Opera, Alexander Gibson.

CREAR
KINTYRE

Crear is a working space on the west coast for musicians to rehearse and work on collaborations. It hosts intimate concerts, often profiling the work of those musicians who've been in residence. Recent performances have included those by the Scottish Ensemble and the Scottish Chamber Orchestra.

FINGAL'S CAVE
ISLE OF STAFFA

This natural cathedral formed by basalt columns so impressed Felix Mendelssohn in 1829 that he devoted a movement of his *Hebrides Overture* to it. The Mendelssohn on Mull festival is directed by Levon Chilingirian and brings young chamber musicians to the island.

DUNDEE

PERTH

EDINBURGH

STIRLING

GLASGOW

ARRAN

MULL

JURA

ISLAY

minors in a major key

Community orchestra The Big Noise is something to shout about and the children of Raploch are the living proof, as Mark Fisher discovers

Musical director Francis Cummings takes his place in front of the 40-strong orchestra and raises his arms, poised to launch into Henry Purcell's 'Rondeau' from the *Abdelazar Suite*. 'No counting to three, because that's for children,' he says. The musicians duly burst into the opening bars without missing a beat.

Nothing unexpected there, except for one thing: counting to three may be for children, but not one of Cummings' players is older than 12.

'They treat us like grown-ups, like mature people,' says cello player William, on the day before his 11th birthday. The children return the compliment with their impeccable behaviour.

Even at this early rehearsal, it's astonishing to see such young musicians perform with so much precision. It was more astonishing still when, on 21 June 2012, they took to an outdoor stage in the shadow of Stirling Castle as the opening act of the Big Concert, conducted by the exuberant Gustavo Dudamel in front of a national television audience.

Some of them even stayed on stage to join the 200-strong Simón Bolívar Symphony Orchestra for the overture from Beethoven's *Egmont*. How it is even conceivable for a primary school orchestra to share a stage with such internationally celebrated company is down to the pioneering Big Noise project. Based in Raploch, a short walk from the centre of Stirling, this £3.8m scheme was launched in 2008, drawing on the inspiration of the same 'El Sistema' philosophy in Venezuela that produced the Simón Bolívar Youth Orchestra.

In a community of only 3000, there are 450 children under the age of 12 who have joined after-school rehearsals up to four nights a week. By working collectively and intensively, they are able to race ahead. Even some of the youngest are able to sight-read. Everyone learns together, no one is turned away and the results, both musically and socially, are breathtaking.

'They took to it straight away,' says local volunteer Cath, who has watched with pride as her five children have taken up flute, percussion, viola, violin and cello. 'It's changed them completely. It's brought them closer. Before they used to bicker, now it's just singing, dancing and playing their music. They're a lot more settled, a lot more focused . . . it's brought a new light everywhere.'

The Big Noise approach is to treat the orchestra, with its need for cooperation, good behaviour and sharp focus, as a learning ground for being a responsible citizen. It's something fellow parent Charlotte has seen in practice: 'They're a lot more disciplined and have more respect towards people,' she says. 'When they've got a concert, they're like adults – they're sat there and quiet. It's amazing.'

This afternoon, it seems every room in the Raploch Community Campus is vibrating with musical activity. In the school hall, the youngest class is sitting at primary-coloured music stands while violinist Guido de Groote introduces them to notes and rests. To answer questions, they raise their bows in the air. 'That's the best bow hand you've ever had,' he tells one little girl.

In a nearby classroom, the next age group is working its way up the scale of G major in the hope of winning the Kit Kat taped to the whiteboard by cellist Josip Petrac. When he tells them it's time to move on from a harmony exercise, all 30 of them groan in disappointment.

With a generation of sight-reading musicians about to hit secondary school, the possibilities for the future are mouth-watering. Bolstered by the success so far, Big Noise has ambitions to open three children's orchestra centres in 2013. 'Heaven knows what kind of hip hop will come out of here and genres of music we've not even heard of yet,' says George Anderson, one of the Big Noise team. 'What will these kids do when they know how to arrange a string quartet and put samples on it and use beat boxes?'

makeabignoise.org.uk

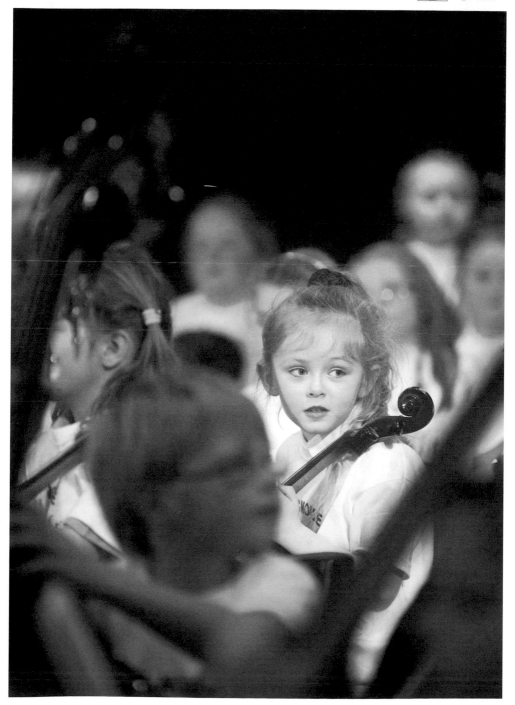

TAKE 10
scottish club promoters

David Pollock introduces the organisers of Scotland's best parties

OPTIMO

Scotland's most credible and internationally recognised underground club until it closed its weekly Sunday nighter at the Sub Club a couple of years ago, Optimo, aka JD Twitch and JG Wilkes, still promote a bi-monthly collision of post-punk, electro, techno and ludicrously wide-ranging styles at the same venue, as well as DJing internationally and promoting occasional one-off dates.
optimo.co.uk

SLAM EVENTS

Founded by Scots house duo Slam alongside their record label Soma, Slam Events promotes two high profile, guest-led events in Glasgow – Pressure at the Arches and Return to Mono at the Sub Club, both monthly – and also programmes the dance-led Slam Tent at Scotland's T in the Park festival every year.
slamevents.com

HIGHLIFE

Run by Glasgow DJ and promoter Brian d'Souza, who also produces music under the alias Auntie Flo, and Andrew Thomson of the now London-based night Huntleys & Palmers, Highlife's monthly dates at the Sub Club in Glasgow and occasional one-off dates elsewhere are musically forward-thinking, drawing influence from South American and African dance music.
facebook.com/ subclub

TROUBLE

Originally a single regular club night, Edinburgh-based Trouble is now an umbrella for the activities of DJ and promoter Andrew 'Hobbes' Richardson, who has run a variety of genre-specific nights, including Wonky and Devil Disco Club, as well as highly regarded local band night Limbo Live and a range of gig promotions for Trouble-friendly artists like Alice Russell and The Black Seeds.
getintotrouble.com

MUSIKA

Edinburgh's current largest club music promoter, with a regular monthly party at the Liquid Room and occasionally at other venues around the city. Special Hogmanay and Edinburgh Fringe events and a regular monthly night brought guests including Carl Cox, Simian Mobile Disco, Julio Bashmore, Visionquest and John Digweed to the city in 2012.
musikanights.com

COLOURS

One of the biggest promoters in Scotland and the country's go-to organisation for trance and commercial house parties, Colours runs a regular special guest night at the Arches in Glasgow, as well as one-day festival event Coloursfest at Braehead Arena and the new Party in the Park at Strathclyde Country Park as of September 2012.
colours.co.uk

BIGFOOT'S TEA PARTY

A relatively young promoter staging regular events in Aberdeen and occasional parties in Glasgow, the latter including a bunch of exclusive large-scale outdoor shows next to the former home of the Tall Ship on the banks of the Clyde, with a selection of cutting-edge house and techno guests also appearing.
facebook.com/ bigfootsteaparty

XPLICIT

Since 2005, the premier promoter of drum 'n' bass nights in Edinburgh and therefore Scotland, the style being much more prevalent on the east coast than on the west. The regular, guest-led Xplicit night has been held at various venues and has latterly drawn dubstep into its remit, giving big names like Pendulum early Scottish exposure.
facebook.com/ xplicitscotland

ELECTRIC FROG

Although it has scaled down its operations from a recent rate of multiple weekenders per year, Electric Frog still holds occasional parties at feted underground warehouse venue/ art gallery SWG3, welcoming expertly chosen guests including Adam Beyer, Surgeon, Jeff Mills, Frankie Knuckles and occasionally touring live bands.
theelectricfrog. co.uk

ASTROJAZZ

With a dedication to global music alongside styles such as dubstep and hip hop, Astrojazz' Chris Knight (aka DJ Astroboy) is one of the promoters behind popular monthly Edinburgh night Four Corners, as well as organising occasional events, festival stages and DJ appearances around the country under the Departure Lounge and Samedia banners.
astrojazz.co.uk

LOOK HERE

Art & Design

When it comes to creating possible worlds, Charles Avery is your man. His *Islands Project* is a vivid example of the kind of imagination Scotland's gallery goers have come to expect from their visual artists and designers . . .

everyday miracles

Scotland, and especially Glasgow, emerged in the late 20th century as a hotbed of talent in the fine arts. Rosalie Doubal finds out how it wasn't all down to chance

A country recognised for its commitment to supporting young visual artists and their DIY endeavours, Scotland has planted a well-earned flag on the international art map. Scooping 11 Turner prize nominations and six winners in the past 15 years, a generation of Scottish artists has garnered great attention, helping to assert Glasgow's position as a major centre for UK visual art. Curator Hans Ulrich Obrist once described the success of this artistic community as a 'miracle'. Divine intervention, however, has nothing to do with it.

Tasked with investigating the conditions that encouraged the renaissance of the visual arts in Glasgow, the director of the city's Centre for Contemporary Art, Francis McKee, is undertaking an archival research project with artist Ross Sinclair. 'The Glasgow Miracle: Materials for Alternative Histories' traces the emergence of the Glasgow art scene from its roots in the early 1970s, through the successes of painters in the 80s, and the growth of a DIY culture in the 90s and beyond.

'The punk explosion had a great impact in Glasgow,' says McKee. 'Doing it for yourself right here, right now, rather than thinking only American or continental artists could achieve things in the art world.'

He points to the similar development of visual art scenes in other so-called 'marginal cities': 'Seattle, Glasgow, Malmö – places that would have felt out of the mainstream became important, as travel and communication evolved and it was possible to be internationally successful and stay in these places.'

The achievements of the city's scene can be also be attributed to the famous Glasgow School of Art. 'It can't be a coincidence that the 80s and 90s generation were the result of free education, free grants for university and college education – the deliberate educating of a class that had always been ignored,' says McKee. 'That education policy brought through far more talent across the social classes and the British art world stopped being the preserve of the rich and expensively educated.'

It was a social shift that affected the art that was produced in the 80s and 90s. 'Ken Currie looking at the shipyards and unions, Douglas Gordon and Roddy Buchanan looking at football and B-movies, and Jackie Donachie looking at country and western singers in Glasgow bars,' he says.

Looking beyond the walls of Mackintosh's revered Glasgow building, several other colleges across the country have nurtured considerable skill, not least Dundee's creative centre. 'Duncan of Jordanstone has produced great talent that rivals that of Glasgow School of Art,' says Dundee Contemporary Arts curator Graham Domke. 'The 2006 Tate Triennial was a good example, where DJCAD graduates Lucy McKenzie, Luke Fowler, Scott Myles, Alan Michael and Christopher Orr were all included.'

Again attributing the nation's wealth of talent to a self-starting approach, Domke celebrates the Dundee scene: 'It's a compact and connected city. We benefit enormously from there being an artist-run space like Generator, initiatives like Yuck'n'Yum and newer projects like the studio collective Tin Roof. These are vital to the feeling that Dundee has reinvented itself through cultural confidence.'

It's to a younger generation of artists and organisers that we now look to continue the communal atmosphere of support. Edinburgh artist Jonathan Owen attributes Scotland's nurturing environment to the strong gallery sector: 'There are incentives for young artists to stay here, contributing to and benefiting from internationally active organisations – DIY artist-run initiatives, publicly funded galleries and workplaces, and high quality commercial galleries.'

Glasgow-trained artist Bobby Niven says he has benefited from such schemes: 'I had a really amazing experience working with Peacock Visual Arts in Aberdeen recently and I think the funding of art organisations on the geographical periphery is vital in providing a diversity of experiences.'

We can be thankful for a nationwide tradition of committed educators, progressive programming and mutual support among practitioners. In the words of artist Nathan Coley's 2006 neon epithet – 'There will be no miracles here.'

> *'The British art world stopped being the preserve of the rich'*

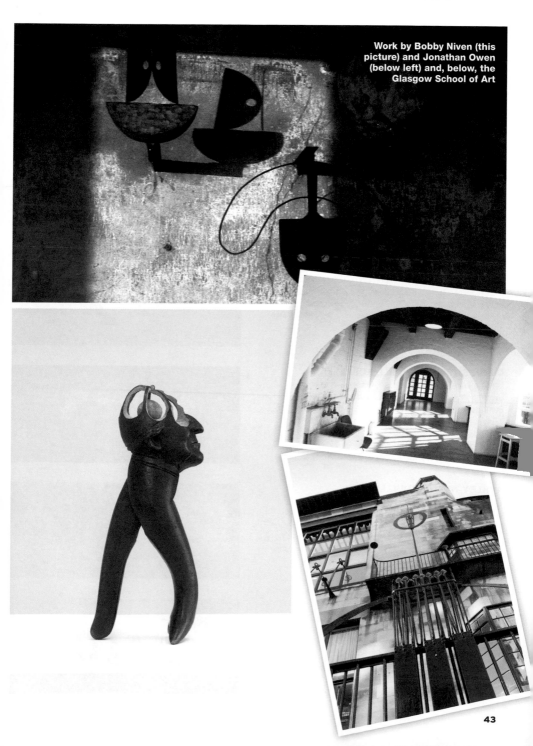

Work by Bobby Niven (this picture) and Jonathan Owen (below left) and, below, the Glasgow School of Art

TAKE 10
emerging artists

NICK EVANS

The work of Glasgow sculptor Nick Evans makes reference
to art history and traditional practical application, but adds a
modern twist. Whether his sculptures are chunky and inward
looking, or fleshy and exhibitionist, they provide a feast for
tired dry eyes. He has had shows at the Scottish National
Gallery of Modern Art, GoMA and the Mackintosh Museum.
Represented by Mary Mary, marymarygallery.co.uk

TORSTEN LAUSCHMANN

Highly regarded yet steadfastly independent, German-
Glaswegian Torsten Lauschmann consistently enchants his
audiences and leaves them begging for more. His intelligent,
witty and engaging video, light and sound installations
construct a narrative exploring the technology, both ancient
and modern, that produces them.
torstenlauschmann.com

CORIN SWORN (KENDALL KOPPE)

London-born, Vancouver-raised, Glasgow-based Corin
Sworn, who represents Scotland at the 2013 Venice
Biennale, is a true master of fine art. Her thought-provoking
work explores the stories we attach to objects, allowing
poetry to erupt at the intersection between aesthetic form and
meticulously constructed content.
Represented by Kendall Koppe, kendallkoppe.com

ASHLEY NIEUWENHUIZEN

The work of the Dundee-based artist is a response to the
wild nature of her South African homeland. By using raw
materials and her own body, she investigates the fantastical
and scientific realms where aspects of animal and man blend.
Through sculpture, printmaking, performance and drawing,
she makes us think twice about our environment.
morphbody.weebly.com

TATHAM O'SULLIVAN

Active art duo Joanne Tatham and Tom O'Sullivan have worked
collaboratively since 1995, examining the modern world through
absurd and often contradictory interventions. They use sculpture,
painting, architecture, photography, performance and literature to
create diversions and unpick washed-out terminology.
**Represented by the Modern Institute,
themoderninstitute.com**

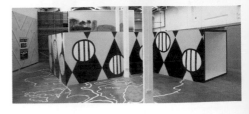

Producing six of the last 15 Turner Prize winners – among them Martin Creed, Richard Wright, Susan Philipsz and Simon Starling – the Scottish art scene is an incubator for new international talent. Talitha Kotzé introduces ten of the best

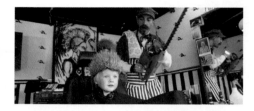

85A
In a 21st-century riff on the avant garde spirit, the unstoppable Glasgow collective 85A is a group of multidisciplinary artists who put on experimental shows. Their repertoire stretches from music events and film screenings to multisensory kinetic theatre, an herbaceous barbershop and hedonistic Hallowe'en and Christmas parties.
85a.org.uk

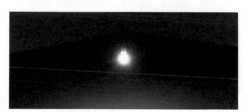

KATIE PATERSON
Katie Paterson has exhibited at the Tate Triennale, Modern Art Oxford and BALTIC. She likes to make cosmological interventions, transmitting Beethoven's *Moonlight Sonata* to the moon and back, wiring a live phone line to an Icelandic glacier and mapping out the locations of the 27,000 dead stars known to humanity.
Represented by the Ingleby Gallery, inglebygallery.com

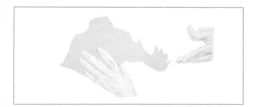

CHRISTINE JONES
In the drawings of Falkirk artist Christine Jones, subtle monochromatic tones emerge powerfully from the surface. She has been commissioned to do illustrations of musicians, filmmakers and other beautiful people, and is working on a project focusing on the legacy of photojournalism and the Spanish Civil War.
cargocollective.com/christinejones

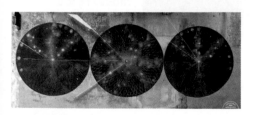

MARK LYKEN
Mark Lyken is a visual artist and musician based in Glasgow. Interested in how personal technology and social networks are becoming the glue that binds society, he creates abstract meditations on the digital world. In 2012, he had a solo exhibition at street art and graffiti gallery Recoat and released a debut album.
Part of the Recoat collective, recoatdesign.com

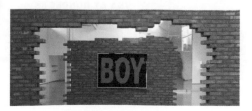

SCOTT MYLES
Dundonian Myles' work is held in the Tate, MoMA, Scottish National Gallery of Modern Art and GoMA. He works with printmaking, sculpture and architectural structure – he often builds additional walls within galleries. For his DCA solo show in 2012, a wall was erected by apprentices from Angus College.
Represented by the Modern Institute, themoderninstitute.com

TAKE 10
art institutions

NATIONAL GALLERIES OF SCOTLAND
Four sites across Edinburgh house the national collections. Among the permanent highlights are work by Titian, Rembrandt and the great surrealists.
nationalgalleries.org

GALLERY OF MODERN ART
A grand neo-classical building in the middle of Glasgow, housing the city's art collections and hosting exhibitions by local, national and international artists, as well as an art and social justice biennial. **glasgowlife.org.uk**

DUNDEE CONTEMPORARY ARTS
Forward-thinking contemporary art gallery, with a busy programme of arthouse cinema, plus print studio. DCA curated the first major solo shows by Martin Boyce and Ruth Ewan. **dca.org.uk**

FRUITMARKET GALLERY
This independent venue for large-scale contemporary art has hosted career-defining shows by Lucy Skaer, Toby Paterson, Nathan Coley and more in an airy central Edinburgh space.
fruitmarket.co.uk

THE LIGHTHOUSE
The national centre for architecture and design is housed in a building by Charles Rennie Mackintosh, later adapted by Gareth Hoskins Architects. It has a display on Mack himself and a digital fabrication facility.
thelighthouse.co.uk

TRAMWAY
Described by Peter Brook, the director who precipitated its transformation from a transport museum, as 'an industrial cathedral that connects art with humanity', this cavernous Glasgow venue houses large-scale art.
tramway.org

MOUNT STUART
This idiosyncratic Gothic mansion on the Isle of Bute houses 128 classical portraits. But it's the annual summer exhibition – which has featured Moyna Flannigan, Lee Mingwei and Katja Strunz – that makes it stand out. **mountstuart.com**

DUFF HOUSE
A William Adam masterpiece of 1735 in the Aberdeenshire countryside, this outpost of the National Galleries of Scotland has shown works by El Greco, Gainsborough and Raeburn and one special 'masterpiece' loan a year. **duffhouse.org.uk**

TRONGATE 103
A warehouse conversion in Glasgow's Merchant City, housing organisations including Street Level Photoworks, Project Ability, Glasgow Print Studio, Sharmanka Kinetic Theatre and a Russian café-gallery. **trongate103.com**

V&A AT DUNDEE
It's not been built yet (Japanese architect Kengo Kuma and Scottish practice Cre8architecture are in charge of that), but the V&A is sure to be an asset to Dundee's already lively waterfront area.
vandaatdundee.com

green, green grassroots

David Pollock rounds up some of Scotland's finest artist-run galleries and collective studio spaces

Scotland's major cities each enjoy a healthy do-it-yourself arts scene, with many collectively run spaces holding exhibitions and providing working studio environments. Among the current key spaces in that hotbed of Turner-prize winning talent, Glasgow, are the Glue Factory (thegluefactory.org), an industrial space that runs exhibitions and events and hosts print and recording studios; the Pipe Factory (thepipefactory.co.uk), a new studio space that also produces publications; and SWG3 (swg3.tv), an exhibition and performance-based warehouse venue that sponsors four graduates per year with studio space. Ironbbratz (ironbbratz.wordpress.com) is also a popular studio provider.

Some of the more well-known grassroots galleries in the city, meanwhile, include the committee-run Transmission (transmissiongallery.org), the Duchy (theduchygallery.com) and the Telfer (the-telfer.com), while the Mutual (themutual.org.uk) is an artists' collective responsible for a number of creative 'interventions' during the 2012 edition of the Glasgow International biennial. Many similar organisations abound in Edinburgh, particularly amid the lower-rent industrial areas of Leith, including studio galleries Superclub (superclubstudios.com) and Rhubaba

(rhubaba.org), and DIY galleries the Old Ambulance Depot (theoldambulancedepot.co.uk) and Whitespace (whitespace11.com).

Elsewhere in the city, the Embassy (embassygallery.org) is an annually-renewed collective of Edinburgh College of Art's most promising graduates that also stages regular exhibitions, and the Collective Gallery (collectivegallery.net) is a long-established and centrally located gallery with a particular interest in supporting new visual artists. The Glasgow Sculpture Studios (glasgowsculpturestudios.org), Edinburgh Sculpture Workshop (edinburghsculpture.org) and Scottish Sculpture Workshop (ssw.org.uk) near Huntly all offer exhibitions, studio space and technical support.

As the third of Scotland's cities with a major art school, Dundee is served by long-running exhibition and project space Generator Projects (generatorprojects.co.uk) and recently established collective Tin Roof (tinroofdundee.org), while similar organisations further north include Aberdeen collective Limousine Bull (limousinebull.org.uk) and Inverness arts space IG:LU (theig.lu). Finally, an indispensable country-wide resource is WASPS Studios (www.waspsstudios.org.uk), which offers artists working spaces in the major cities and in locations as diverse as Kirkcudbright and Nairn.

postcards from

Scotland is full of stunning landscapes – so it's only natural that visual artists, galleries and curators have made full use of them in locations around the country. Laura Ennor goes on a journey

Pier Arts Centre, Orkney

West Kilbride, Craft Town Scotland

Little Sparta

PIER ARTS CENTRE, ORKNEY

On his native isles' proliferation of artists, Orcadian writer George Mackay Brown once wrote, 'I am sure that good art springs from . . . fruitful contact with the elements.' The Pier, set up to provide a home for the collection of author and philanthropist Margaret Gardiner, could not be closer to the elements, perched as it is on the water's edge in the fishing port of Stromness. In keeping with its traditional and natural environment, yet strikingly modern in design (the work of Edinburgh architects Reiach & Hall), its contemporary art programming is as forward thinking as any city-centre venue and arguably more excitingly positioned.
pierartscentre.com

WEST KILBRIDE, CRAFT TOWN SCOTLAND

An initiative in the 1990s led to the North Ayrshire coastal community of West Kilbride bucking a trend for town-centre decline by playing up to its strengths in craft and design. It's now Scotland's only official Craft Town, and has a stunning new converted church venue to match: the Barony Centre houses displays of work from the dozens of crafty cottage industries in the town, as well as touring exhibitions and participatory activities to engage community and visitors alike.
crafttownscotland.org

LITTLE SPARTA

The life's work of poet, artist and 'avant-gardener' Ian Hamilton Finlay, Little Sparta is the garden of his former home in the Pentland Hills, south-west of Edinburgh. The garden itself is a high-concept artistic creation, advancing Finlay's ideas about art, beauty, and mankind's duty to morality, as well as containing over 270 individual art works. Some of these are collaborations with stonemasons and letter-cutters that give almost literal meaning to the idea of 'concrete poetry'.
littlesparta.org.uk

scotland

DEVERON ARTS, HUNTLY

The mantra of Aberdeenshire organisation Deveron Arts is 'the town is the venue' – and the history and heritage of the market town of Huntly also informs the content of much of what it does. The work, which is resolutely participatory and engaging, explores socio-economic, environmental and heritage issues relevant to Huntly and the wider world. Recent work has explored walking, borders and the realities of living in a small community, and the organisation also lays on the annual Hallowe'en Hairst festival.
deveron-arts.com

TAIGH CHEARSABHAGH, NORTH UIST

Galleries don't come much more remote than this. In the village of Lochmaddy (population 300) Taigh Chearsabhagh's location on the remote, exposed, low-lying Hebridean archipelago informs its focus on environmental art. In the bay it overlooks is artist Chris Drury's 'Hut of the Shadows', a stone chamber acting as a camera obscura for the image of the loch-strewn landscape beyond.
taigh-chearsabhagh.org

JUPITER ARTLAND

Opened in 2009 by owners Robert and Nicky Wilson, Jupiter Artland combines art and landscape to magical effect in a location easily accessible from the capital. The sculpture park's permanent features were all constructed in-situ and the relationship of each to its topographical location is a crucial feature. They include works by Andy Goldsworthy, Ian Hamilton Finlay (whose own Little Sparta inspired the park's creation), Charles Jencks, Anish Kapoor, Peter Liversidge and Cornelia Parker – joined by temporary and new permanent creations each summer season.
jupiterartland.org

TIMOROUS BEASTIES

This Glasgow design studio has been leading a mission against twee textiles for over 20 years, picking up an armful of awards and famous fans along the way. Best known for provocative, contemporary takes on the *toile de jouy* fabrics of Napoleonic France, it also makes wallpaper, lace, lighting, rugs and ceramics. **timorousbeasties.com**

design for life

This Scottish shopping basket shows that the country's design industries are nothing if not diverse: from traditional woven textiles to the cutting edge of service design, we've got it made

HARRIS TWEED

To carry the official 'orb' symbol of authenticity, Harris Tweed must have been made in the Outer Hebrides in the traditional manner – and yards and yards of it are, every year. A large proportion of that output goes to fashion houses ranging from that of the late Alexander McQueen to Sara Berman and, in 2004, even to Nike for a limited run of Harris Tweed 'retro' trainers. **harristweed.org**

BLUE MARMALADE

A furniture and product design company with an emphasis on eco-friendly design, Edinburgh's Blue Marmalade does not turn out the homespun sort of aesthetic you might expect from such an endeavour: browse its website and you'll find bright colours, clean lines and striking contemporary design, plus the eco credentials of each item.
bluemarmalade.co.uk

LINN AUDIO EQUIPMENT

A name familiar to audio geeks the world over, Linn was founded in Glasgow in 1973 and produced the highly successful Sondek LP12 turntable. It's still there today, producing top-of-the-range audio equipment with a sleek look for the music fan who's serious about sound.
linn.co.uk

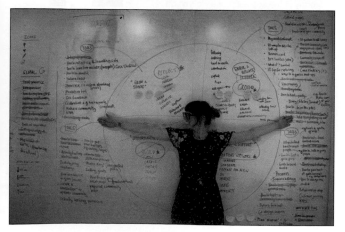

SNOOK

Leading the way in the relatively young discipline of service design (designing systems and user interactions in all sorts of contexts) is this Glasgow start-up founded by two graduates in 2009. From creating a new way of interacting with the police to development work with Festivals Edinburgh, it has done a lot in a very short time, and its commitment to doing it in Scotland, with social change never far from the top of the agenda, is admirable.
wearesnook.com

a scottish fashion parade

as chosen by Jonathan Daniel Pryce

TESSA HARTMANN
Founder of the globally recognised Scottish Fashion Awards and newly announced WGSN (Worth Global Style Network), Hartmann truly deserves a mention on this list. She judge has worked tirelessly over the past decade to give Scottish fashion a platform and for that, I salute her. **hartmannmedia.co.uk**

WILLIAM CHAMBERS
Despite being the new boy in town, Chambers has forged a name for himself in the world of millinery through sheer talent. Based in Glasgow, he sells his designs to an army of women internationally including Kelis and Róisín Murphy. **williamchambers.co.uk**

COMMON PEOPLE
With the high street dominating retail, it's near impossible to get your hands on something different and long-lasting in affordable men's fashion. I discovered Edinburgh-based Common People last season and was happy to hear it's the latest project of Kestin Hare, the former head of design at Nigel Cabourn. The label may have only just launched but with a strong first season, locally sourced and produced where possible, I've finally got my needs met. **commonpeopleclothing.co.uk**

BEBAROQUE
Mhairi and Chloe, the Bebaroque girls, have been making fashion waves since 2007 and I've been following their journey with pride and excitement since day one. Managing to make crystal bodywear synonymous with their brand, they embody all the fashion ideals: luxury, glamour and craftsmanship. **bebaroque.com**

EUAN MCWHIRTER
Scotland's rich heritage and reputation for the highest standards in production means that jewellery should be an important export. This is something Euan McWhirter understands well, producing a range of exquisite jewels worthy of the adoration of a Hollywood star. His use of Swarovski and coloured gems makes him a master of his craft. **euanmcwhirter.co.uk**

REBECCA TORRES
Creating a recognisable brand is hard to do in fashion, with its demand for constantly updating trends. Torres has done it with ease, showing an expert skill in body-conscious dressing, using colour, geometry and a whole lot of lycra to great effect. I don't know a Scottish girl who doesn't own (or want to) one of her dresses and since launching on ASOS, she's exploded. What's the best testament to style credentials? Compliments from *Vogue* – enough said. **rebeccatorres.co.uk**

ABOUT THE WRITER:
Scottish photographer Jonathan Daniel Pryce established successful style blog Les Garçons de Glasgow before moving to London to continue his activities with Another Garçon and, as of summer 2012, a new project: 100 beards, 100 days. He was named Young Photographer of the Year at the 2012 Scottish Fashion Awards.

TAKE 5
Scottish buildings

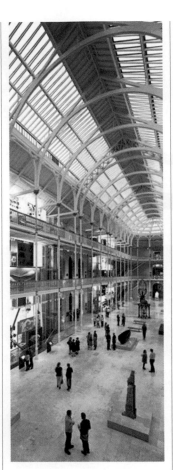

NATIONAL MUSEUM OF SCOTLAND
Gareth Hoskins Architects
Completed 2011

Roundly hailed as a triumph, the renovation of the somewhat tired and dark National Museum in Edinburgh saw the opening up of the splendidly light central atrium space and the creation of several new galleries and a subterranean entrance cavern.

BRITISH HIGH COMMISSION, COLOMBO, SRI LANKA
Richard Murphy Architects
Completed 2008

This diplomatic seat employs an unusual single-storey design with a system of interlinked courtyards and thermal chimneys inducing through breezes and thus reducing the need for air conditioning. Despite climate and security considerations, Richard Murphy and practice managed to make this an attractive and pleasant workplace.

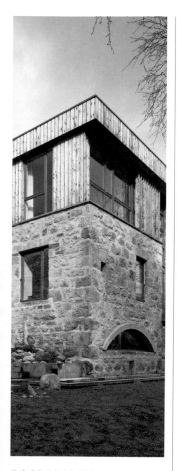

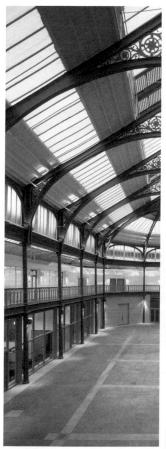

BOGBAIN MILL, LOCHUSSIE
Rural Design Architects,
Completed 2011

This private house from Alan Dickson's Skye-based practice was garlanded with awards from both RIBA and RIAS in 2012 for its sensitive incorporation of the ruins of an old mill into a striking modern design centred on an internal courtyard that provides shelter from those biting Highland winds.

THE BRIGGAIT
Nicoll Russell Architects,
Completed 2010/11

A loving retrofit of this Grade A-listed former fishmarket was achieved by Dundee-based Nicoll Russell in two phases over 2010 and 2011. Some less successful 1980s adaptations were removed from the main hall, revealing a large and elegant space, while other areas were converted into much-needed studios for Glasgow's flourishing creative community.

GLASGOW QUAY PLAN
icecream architecture
workshop/plan

icecream is an 'interactive practice' interested in consulting and workshopping with clients and the community to develop ideas for architecture and masterplanning. As well as traditional design and public art interventions, it has run a number of workshops for kids and adults at the Lighthouse in Glasgow, including one exploring the possibilities for a new-look Glasgow Quay.

developing talents

Three of the most promising photographers to emerge from the Scottish art schools in recent years

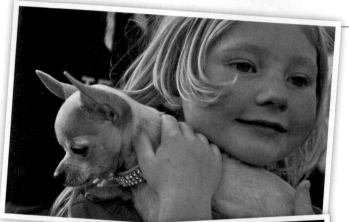

ANNA BRUCE

A graduate of Edinburgh College of Art, Bruce is interested in the layering of ideas and textures, as well as an appreciation of the sculptural quality of the light beam. Most recently, she documented a cultural project called Industri-us on a spill-over site of the London Olympics.
annabruce-stills.com

PHILIP REID

Reid is a fine art photographer from Aberdeen who graduated in 2010. He has an impressive portfolio of freelance clients, as well as ongoing gig photography and projects that have explored obsolete gadgetry, greenery by night and more.
philiptakesphotos.com

STANLEY ALLEN

Allen's work in the 2012 Glasgow School of Art Degree Show got him noticed by the curators of Futureproof, an annual new graduate showcase at Street Level Photo Works. He typically creates large, abstract composite images, with a recent focus on the sky, ground and water.
stanleyallen.com

WORD UP!

Writing

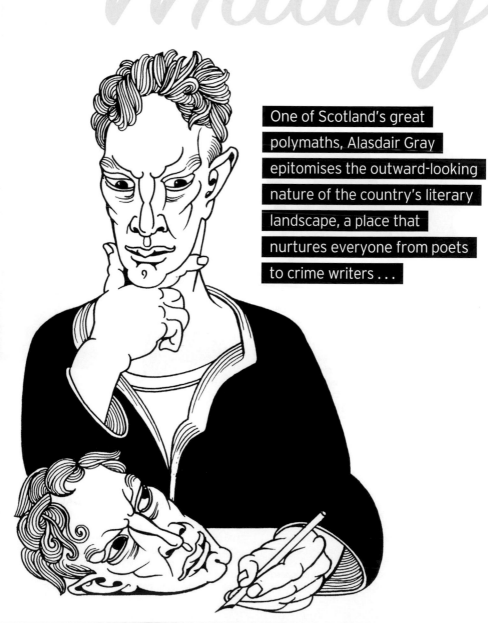

One of Scotland's great polymaths, Alasdair Gray epitomises the outward-looking nature of the country's literary landscape, a place that nurtures everyone from poets to crime writers . . .

the pathfi

RODGE GLASS ON ALASDAIR GRAY

As Gray's secretary, I watched him carve his sentences out first-hand, seeing how he always sought clarity in the fewest words possible.

That was my writer's education. In studying his life and work for my biography of him, I came to appreciate the breadth of his influence, and I now think of him as not only an artist but also a democratiser. Everything he creates is about fairness, as shown in his Òran Mór mural, where Adam and Eve find their place in among the characters of Glasgow's West End. Neither is more important.

EWAN MORRISON ON JAMES KELMAN

For over a decade, Kelman has been forcing me to attempt new strategies. In my mind, he stands for purity of aesthetic, for local language as a barricade against forces of the Empire. His weapon is a Scottish vernacular, honed by the austerity of high literary modernism: a language of the oppressed. Politically, he believes in the authenticity of the working class. And all this to me was lifeless, dead already, sapping my ability to write.

So to Kelman's high modernist austerity, I proposed postmodern montage. To Kelman's male-dominated working class, I offered multicultural gender benders. Against his true local vernacular, I had characters who quoted ads, jingles, pop songs and reclaimed texts. Against his Scottish socialism, I proposed that, loathe it or not, we've become capitalists.

But after a decade of writing, it turns out that global consumerism is a darker, emptier place than even the ruined socialism of Kelman; and very little can grow under its shadow. So I've come full circle. I find myself agreeing

with Kelman. Strange indeed, that his words could have such power; that they are an entire world that I tried to escape from and have now come home to accept. I have never really left the gravitational pull of the universe of Kelman.

KERRY HUDSON ON JANICE GALLOWAY

Janice takes the hard parts of her life and turns them into a gift so others might bear their own hard things a little easier. Reading her books, so fiercely intelligent, intimate, funny and sad, somehow gave me permission to not try to explain my own book, to let the reader make their own interpretations. She has influenced me hugely

ders

Brian Donaldson hears from some of the Scottish literary scene's younger writers about the figures whose influence has driven them on

experience life. You can't bring something to life until you've touched it, tasted it, smelt it. To me, Alan Spence is a writer who cannot be pigeonholed. His writing is Scottish yet international, philosophical as well as telling a story. A novelist, a short story expert, a master of haiku: he can do everything.

ALLAN WILSON ON AGNES OWENS

and continues to inspire me to write what I feel I need to, with total honesty, as well as I possibly can and be unapologetic in doing so. For that I am hugely grateful to her.

CATRIONA CHILD ON ALAN SPENCE

I don't remember everything that I was taught as a student, but I have held on to what I was taught by Alan Spence about creative writing. Alan's classes were a joy, a release from the stifled academic work I was doing in other classes. At the end of each one, we would spend five or ten minutes of free writing – just picking up the pen, emptying our heads, seeing where it took us. It was so liberating!

He gave us valuable advice about being a writer: travel,

For whatever reason, Owens has not enjoyed the same recognition as many of those who have previously championed her work – Gray, Kelman, Lochhead – but her writing deserves to be ranked alongside these writers in terms of its quality. In her short stories, novellas and novels, Owens writes about universal issues like loss, death, love, hate but it's the specifics that make the work so good.

She writes about children and families as well as anybody. There's always danger behind a wall or in the next room and something that comes up a lot in her work is the moment in a young person's life when innocence ends. Many of her stories are sad but within the tragedy there's always humour. I read her when I need to laugh and when I need a reminder that we can write whatever the hell we want.

publish and be charmed

Charlotte Runcie meets the innovative companies
keeping Scotland's literary scene buzzing

Left to right: Gavin MacDougall of Luath, Adrian Searle of Freight and the team from Cargo

If one press has led the way in Scottish publishing, it's Canongate. The team may be relatively small, but since Yann Martel won the Booker for *Life of Pi* in 2002, its global impact has been difficult to ignore. Canongate now publishes Barack Obama's autobiographies as well as work by Nick Cave, Philip Pullman, Alasdair Gray, Margaret Atwood and David Shrigley.

But where once Canongate was a bold but solitary outpost of indie British publishing success, the Edinburgh-based outfit has gained some vibrant contemporaries. Diversity and innovation are mounting, and with them the hopes of a rosy future for books in Scotland.

Luath Press is just one of the creative organisations bringing variety to the nation's bookshelves. Director Gavin MacDougall has focused on a mix of genres, meaning that a spine bearing the Luath logo might hold anything from poetry to tourist information. By way of example, in his Edinburgh office MacDougall passes me a cross-section of recent titles: a walking book, a new adaptation of *Ivanhoe*, a collection of poems by Bashabi Fraser . . .

Operating from a cluttered eyrie at the top of the Royal Mile, MacDougall is philosophical about the future of publishing, despite a bleak outlook for high street bookshops and a glut of pulp-worthy books saturating the market. 'There are already too many books published every year,' he says, 'partly because anybody can publish a book incredibly easily and incredibly cheaply.'

But what sets small companies such as Luath apart from the masses is a ready and genuine friendship with authors, combined with a sideways look at the market to find new seams to explore. One of Luath's most successful recent books was a Japanese-language guide to Scotland, aimed at bewildered visitors.

Adrian Searle of Glasgow's Freight Books (publisher of *Gutter* magazine, Toni Davidson and *101 Uses of a Dead Kindle*) is adamant that small Scottish presses have their advantages in a recession, and that perhaps, finally, their

time has come to shine. 'It's a far more level playing field,' he says, as the office dog wanders in to shove a wet nose against my ankle. Because bigger houses have scaled back in the wake of economic uncertainty, 'it's far more affordable to pick up talented fiction writers than it was two or three years ago.'

Small companies have inherent benefits. 'Independents tend to be far more energetic in terms of their marketing, and more imaginative,' he says. 'They have a much closer relationship to their authors.' Searle's first love is Scottish literary fiction – he has an MA in creative writing – and he draws on this love daily in looking after his growing stable of writers.

Having operated previously as a design company, Freight started printing novels only in 2011. It joins another new Glasgow company, Cargo, founded just three years ago by director Mark Buckland. Then a gardener with £800 and zero publishing knowledge to his name, Buckland's passion for books has led to a rapid six-figure turnover, the launch of an eBook label and responsibility for work by over 100 international authors.

Building such a portfolio wasn't easy. 'I think we've got through it by just showing people that we're passionate about books, and that's very simple,' Buckland tells me over drinks in Stereo café as Cargo doesn't run an office. 'If there's no money in it, the people involved are still going to do it because they can't help themselves; they love it so much.'

This attitude may well prove a blessing for new writing in Scotland. Canongate's success, the dynamic landscape of Scottish publishing, is passion-driven rather than profit-obsessed. For Buckland and Cargo, the future is bright as long as they keep that in mind. 'It's a really tough time to sell books, to be a writer or to be involved in publishing. So as far as we're concerned, we're going to keep doing what we love, and we're going to keep doing it bigger and better. Simple as that.'

'We're passionate about books, and that's very simple'

a-z of tartan noir

Briain Donaldson works through the dictionary of Scottish literature's darkest genre

A is for **Aberdeen** While Edinburgh and Glasgow get most of the crime fiction attention, the Granite City has been re-awakened from its seemingly law-abiding slumbers by the likes of writers Lance Black, Bill Kirton and MG Kincaid while Stuart MacBride is a regular on the bestseller lists.

B is for **Bob Skinner** Having read an awful book on holiday in 1989, Quintin Jardine was challenged by his wife to write a better one himself. From that discussion, the 22-book strong Detective Skinner series was born.

C is for **Cops** Yes of course, there are plenty police officers in Tartan Noir, but how many authors have gone from being in the force to penning crime dramas? Not as many as you'd imagine, though Karen Campbell and Craig Russell are two of the more successful Scottish ones.

D is for **Death of a . . .** Robert Carlyle played Hamish Macbeth on the telly, the gentle crime series created by MC Beaton (aka Marion Chesney). All 28 of the books are entitled *Death of a . . .* (dentist, maid, chimney sweep etc) with the sole exception of 1999's A Highland Christmas.

E is for **Ellroy** When describing the success of Ian Rankin, the master of the modern US hard-boiled crime story came up with the term tartan noir. Barko was heard to woof in agreement.

F is for **Femmes Fatales** Alanna Knight, Alex Gray and Lin Anderson are the trio in question who

have gathered together for events under the moniker. Anderson and Gray are also the masterminds behind the recent Bloody Scotland, the first festival dedicated to crime writing in Scotland.

G is for **Garnethill** 'The grand dame of Scottish crime fiction' is one description of the still young Denise Mina and it all began in the late 90s with her Garnethill trilogy starring the resourceful if largely luckless Maureen O'Donnell.

H is for **Historical** Those who have dipped back in time to satisfy a different kind of crime writing fix have been Pat McIntosh (medieval Scotland) and Gordon Ferris (post-war Glasgow).

I is for **Isabel Dalhousie** The lead character in Alexander McCall Smith's *Sunday Philosophy Club* mystery series has been dubbed a mix of Jane Austen's Emma Woodhouse and *Sex and the City*'s Carrie Bradshaw.

J is for **Joppa** Identical crime-writing twins, Morna and Helen Mulgray were born in this Edinburgh suburb in 1939. Their books feature the adventures of customs officer DJ Smith and her indestructible sniffer cat, Gorgonzola.

K is for **Kirkcaldy and Kate Brannigan** The former is the birthplace of Val McDermid, the latter is her PI who starred in 90s books such as *Dead Beat* and *Blue Genes*. McDermid is on the board of her town's football team, Raith Rovers.

L is for **Laidlaw** While James Ellroy may have coined the term, William McIlvanney is considered to have written the first actual book of the tartan noir genre in 1977, with the first of his series of books featuring Glasgow DI Laidlaw.

M is for **Marjory Fleming** Aline Templeton's Galloway-based DI is dubbed 'Big Marge' for her height and feisty nature as evidenced in books such as *Lamb to the Slaughter* and *Cradle to Grave*.

N is for **No Mean City** While the spectre of *Jekyll and Hyde* looms large over Edinburgh's crime fiction fraternity (Ian Rankin has spoken of its influence on him), this 1935 novel by Alexander McArthur and H Kingsley Long reverberates among the Glasgow community with its tale of Gorbals' razor gangs.

O is for **Orkney** The birthplace of Allan Guthrie, agent, editor and writer of hard-boiled crime fiction such as *Two-Way Split* and the very pulpy-sounding *Kiss Her Goodbye*.

P is for **'Plato's Republic with a body count'** This is how one critic described Paul Johnston's Quint Dalrymple crime series set in a futuristic Edinburgh of the 2020s.

Q is for **Quite Ugly One Morning** Christopher Brookmyre introduced us to Glasgow journo Jack Parlabane who stumbles upon the investigation into the murder of a gambling medic in this witty novel.

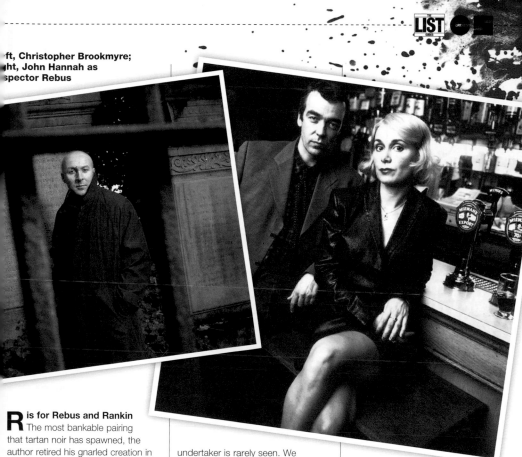

R **is for Rebus and Rankin**
The most bankable pairing
that tartan noir has spawned, the
author retired his gnarled creation in
2007 only to revive him in 2012 with
Standing in Another Man's Grave.

S **is for Straw Dogs** Sam
Peckinpah's notorious psycho-
thriller is based on *The Siege of
Trencher's Farm*, a crime drama from
Gordon M Williams, the Paisley-born
author who collaborated with Terry
Venables on TV cockney cop show,
Hazell.

T **is for Taggart** Pretty much the
best representation of tartan noir
to make it to our small screens, from
the bluesy theme tune, 'No Mean
City', to the dark and brutal realities
of Glasgow crime.

U **is for Undertakers
(Unrepresented)** Given the
stench of death that by necessity
permeates tartan noir, the humble
undertaker is rarely seen. We
have to venture into literary fiction
for one of the best examples, Alan
Spence's *Way to Go*.

V **is for Vet** Manda Scott, author
of *Hen's Teeth* and *Night Mares*,
is a veterinary surgeon. Curiously,
Singing to the Dead writer Caro
Ramsay turned down a place at vet
school.

W **is for Whisky** John Rebus
is certainly known to have
swallowed a dram or two in his time,
while the Mulgray Twins' *Above
Suspicion* is set among the distilleries
of Islay, the same destination for
Doug Johnstone's ex-uni mates in
Smokeheads.

X **is for Exile and Exit Music**
OK, we had to cheat slightly
here, *Exile* being the second book
of Denise
Mina's Garnethill trilogy
while *Exit Music* was supposed to be
Rebus' swansong. I suppose there
must have been lots of X-rays taken
in Scottish crime books, many of
which could be dubbed X-certificate?

Y **is for Young Journalist of
the Year** The award claimed by
Tony Black, whose Edinburgh crime
books include *Truth Lies Bleeding*
and *Long Time Dead*.

Z **is for Zenith** Glenn Chandler
wrote comedy-drama movie
Deadly Advice, starring Jane
Horrocks and Edward Woodward, for
Zenith Productions. The Edinburgh
writer is most famous for creating
Taggart and also penned the DI
Madden books, *Dead Sight* and
Savage Tide.

fiction factory

UNDER THE SKIN (2000)

Set in the Highlands, Michel Faber's full-length fiction debut was a real shock to the system. Isserley is an über-earthly creature with deep scars and thick specs who is on a mission to capture muscle-bound men for creepy experimentation. Read this and you'll give hitchhiking a permanent thumbs-down. You might never set foot on a farm again either.

THE CUTTING ROOM (2002)

The scintillating Glasgow-set debut from Louise Welsh featured an eccentric auctioneer, Rilke, whose uncovering of some erotically violent photographs triggers his own journey of discovery as we lurch from the calm suburbs to a hectic porn industry.

PORNO (2002)

We've recently had *Skagboys*, the prequel to Irvine Welsh's epochal *Trainspotting*, but the sequel is arguably the better (and funnier) book, with Renton returning from Amsterdam and avoiding Begbie like the plague, Spud trying to pen a history of Leith and Sick Boy dipping his sordid wick into the nasty world of adult entertainment.

THE MAN WHO WALKS (2002)

It's been a fine century so far for Alan Warner, and he opened it with this surreal and inventive fable about a drifter on the trail of his uncle who has made off with the local pub's World Cup kitty. Cue a series of mind-squelching encounters with people bearing names such as Jaxter, Liam O'Looney, Raincheck and Syrupy Piece.

BUDDHA DA (2003)

Shortlisted for both the Orange and Whitbread prizes, Anne Donovan's lovely debut novel revolves around painter and decorator Jimmy McKenna's sort-of spiritual awakening (he meets a Buddhist monk in a sandwich bar) and the effect his new karmic outlook has on his wife Liz and their 11-year-old daughter Anne-Marie.

Brian Donaldson picks ten novels that have lit up the nation this century

PARADISE (2004)	**THE ACCIDENTAL** (2005)	**BE NEAR ME** (2006)	**INVISIBLE ISLANDS** (2006)	**AND THE LAND LAY STILL** (2010)
In AL Kennedy's novel, Hannah Luckcraft is an unfailingly kind human being, worn down by always trying to do the right thing in a world where so much is obviously wrong. Her resolution is to steep herself in booze, have a fling with a dypso dentist and discuss in humorous and poignant fashion the contradictions and complexities of her state of being.	Ali Smith followed up her Booker nomination for *Hotel World* with another shortlisted tale, this time featuring Astrid, a 12-year-old girl stuck in a holiday home with her brother, mum and stepdad when the mysterious Amber drops by and changes all their lives.	Another evocative exploration of Scottish identity from the brilliant pen of Andrew O'Hagan as he charts the fall from grace of David Anderton, an Ayrshire parish priest accused of sexual assault on a teenage boy. A book about love and friendship, it also tackles Anglophobia, sectarianism and societal breakdown.	Gaelic writer Aonghas Phàdraig Caimbeul channelled the work of Calvino and Borges for this acclaimed series of 21 fables about a mythical Scottish archipelago which offers a passageway to places as diverse as the Forbidden City, Sistine Chapel and Brandenburg Gate.	A sweeping fiction of extraordinary ambition, James Robertson's fourth novel is an analysis of Scotland from the post-war years to the fevered aftermath of devolution taking in oil, Thatcher and religion, the legacy of war and an uncertain future via the wastelands of a de-industrialised nation.

speak up

David Pollock explores the rise in spoken word events across the nation

Where once the poetry slam was the Scots wordsmith's destination of choice for public verbosity, there are now a growing number of spoken word readings at everything from book festivals to DIY venues. Aspiring writers are quickly catching on to a growing accepted truth of the publishing industry: it isn't enough just to write the words, you can make people care about them quickly by speaking them aloud.

In Edinburgh, one of the more popular events is Inky Fingers (inkyfingersedinburgh.wordpress. com), which runs once a month and welcomes 'poems, rants, ballads, short stories, diaries and experimental texts', while the punk-spirited Neu! Reekie! (neureekie.tumblr.com)

describes itself as 'a monthly headfuck of poetry, animation and music'. One of the newer venues for spoken word events in Edinburgh is the excellent bookshop Pulp Fiction (pulp-books. com), deep in the area that hosts the annual West Port Book Festival (westportbookfestival.org).

Scotland hosts dozens of book festivals and many of these include participatory events. The most renowned of these is the daily 'literary cabaret' Unbound at the Edinburgh International Book Festival (edbookfest.co.uk) every August. In Glasgow, high-profile events include Seeds of Thought (seedsofthought. webs.com), a semi-regular African-themed event showcasing poetry and music, the monthly Reading the

Leaves at Tchai Ovna House of Tea (tchaiovna.com), experimental writers group the Word Factory's monthly Word Play at the Tron (wordfactory. org.uk), Monosyllabic at the Old Hairdresser's, the semi-regular poetry night St Mungo's Mirrorball (stmungosmirrorball.co.uk) and the Rio Café's Last Monday at Rio.

Outside of the Central Belt, events include Poetry Aberdeen (poetryaberdeen.co.uk) and Scotch Corner at the Kay Park Tavern in Kilmarnock. Storytelling groups around the country also hold sessions in Scots and Gaelic, a list of which is found on the website of the Scottish Storytelling Centre (scottishstorytellingcentre. co.uk), which hosts many similar events itself.

strip search

Henry Northmore looks at the country's comics heroes
from Hollywood superstars to local indies

We've always loved comics in Scotland. DC Thomson ruled the roost in kids comics, launching *The Dandy* and *The Beano* in the 1930s. 'Sales peaked at 1.92m a week in the 50s, that's about 100m copies in a year,' says former *Dandy* editor Morris Heggie. DC Thomson was also the breeding ground for the talent that would go on to set up groundbreaking sci-fi anthology *2000AD*; John Wagner, Pat Mills and Alan Grant all started at the Dundee publishing house.

However, when it comes to superheroes, two of the biggest writers in the world, Grant Morrison at DC and Mark Millar at Marvel, are both from the Glasgow area. Through titles such as *The Invisibles*, *Animal Man* and *Doom Patrol*, Morrison brought a new surreal intelligence to the medium, while he continued to subvert the form with his distinctive take on *Batman & Robin*, *All Star Superman* and *JLA*. 'Americans are developing a sense of irony,' says Morrison, 'so they are turning to Scottish stuff which seems to be filled with black humour. Sort of *Clockwork Orange* ultra-violence but always with a smirk on its face.'

Millar thinks it's a question of attitude. 'People say it's our education, but I think it's probably that we have less reverence for authority figures in general, and less reverence for pop culture icons,' he says. 'Americans might be so delighted to be writing these characters that they're scared to take risks, whereas we are a nation of risk-takers.'

Millar started at *2000AD* but went on to write *Spider-Man*, *Ultimate X-Men*, *Fantastic Four* and his own *Wanted* and *Kick-Ass*. Add artists Frank Quitely (*New X-Men/All Star Superman*), Eddie Campbell (*From Hell*) and Gary Erskine (*Judge Dredd/Dan Dare*) and Scotland punches well above its weight.

There's also a thriving underground comics scene, much of which centres on the creative hub that is Glasgow's Hope Street Studios (hopestreetstudios.com) that offers arts, colourists and illustrators studio space. Metaphrog (metaphrog.com), home to *Louis* and *Strange Weather Lately*, is another independent success story also based in Glasgow.

There may not be as much money involved, but the small-press scene is alive and kicking – artists and writers such as Iain Laurie (powwkipsie. blogspot.co.uk), Curt Sibling (totalfear.blogspot. co.uk), Craig Collins (craig-collins.blogspot.co.uk), Garry McLaughlin (laseragecomics.co.uk), Jon G Miller and many more are all producing interesting unique work that is well worth tracking down.

well versed

Yasmin Sulaiman speaks to some Scottish poets who pick their favourite lines from a compatriot's work

BRIAN WHITTINGHAM

'Granda, A miss yer voice, A miss yer han'

from 'First Gemme' by Derek Ross

The poem recaptures a boy's association with his grandfather who was taking him to his first football game. It is evocative of a special relationship and experience, the kind that never dies; the reader is immediately carried to their own version of such an event while experiencing the fondness and love embedded in the narrative. The summation of feeling in the last line would bring a tear to a glass eye.

LIZ NIVEN

'We thought we walked by moonlit rills, or listened half the night to hear the spring wind whistling through the hills'

from 'The Voyage' by Edwin Muir

Mystical and magical dreamlike wanderings captured in a few words.

KEVIN MACNEIL

'soillse crwuinne an lasadh t' aodainn'

('lighting of a universe in the kindling of your face')

from 'Dain to Eimhir XVII' by Sorley MacLean

This beautiful line, intimate and all-encompassing, glows with sincerity and love and brings about a kind of mental refulgence. In my reading, Sorley recalls Dante's dazzling phrase, 'the love that moves the sun and the other stars'. It also reminds me of the Buddhist word 'dharmadhatu', the realm of phenomena, often imaged as an endless net of threads (the horizontal being space, the vertical time).

TESSA RANSFORD

'Time, teach us the art/ That breaks and heals the heart'

from 'The Heart Could Never Speak' by Edwin Muir

It's impossible to explain the profundity of these lines, but if they don't refer to poetry I don't know what does.

ALISTAIR FINDLAY

'Mars is braw in crammasy/ Venus in a green silk goun'

from 'The Bonnie Broukit Bairn' by Hugh MacDiarmid

I first read it in A Poet's Quair, a Scottish school's anthology, circa 1962, when I was 13. The language, chewy and alliterative when spoken, compellingly strange visually on the page, a mixture of popular Scots ('braw') and scholarly Scots ('crammasy': crimson), lines, I now know, in which Scottish left modernism met the kailyard, and won, hands down.

SPOTLIGHT ON:

julia donaldson
No rest for the acclaimed children's author

T he job of a Children's laureate is never done. It's not enough for Julia Donaldson to produce her celebrated picture books – favourites such as *The Gruffalo, Superworm, Stick Man* and *Tiddler* with their gorgeous illustrations by Axel Scheffler – and neither is it enough simply to promote them with appearances at book festivals and schools. On top of this, the Glasgow-based author has to make herself available for all kinds of demands along the way.

'I am enjoying it, but it is very full-on,' she says. 'Your diary's pretty full anyway and then suddenly Maurice Sendak dies and Channel 4 News or the *Today Programme* want you to be a spokesperson, so you never know what extra things are going to be thrown at you.'

Undeterred, she's been on the road this autumn doing a six-week tour of British libraries, starting in Thurso and finishing in Carlisle, with dates in Northern Ireland to follow. It's her way of celebrating libraries and protesting against the cuts, using her position to influence an important public debate.

Meanwhile, she feels duty-bound to repay the loyalty of her most exacting of readerships. 'I've just spent the whole day answering fan mail, sitting here writing to these kids,' she says. 'If you get 30 schools writing to you and there's 30 letters from each school and each child asks eight questions, that's tens of thousands of questions a week to answer, so you have to condense it, but I think it's nice to answer.' (Mark Fisher)

TAKE 5
21ST CENTURY
KIDS BOOKS

Selected by Janet Smyth, children and education programme director at the Edinburgh International Book Festival

**ANIMAL ABC:
A SCOTS ALPHABET**
Susan Rennie and Karen Sutherland (Itchy Coo, 2002)

Fantastic illustrations, and a very funny introduction to a menagerie of animals described in Scots.

THE BUNK-BED BUS
Frank Rodgers (Puffin, 2004)

I love the quirkiness of *The Bunk-Bed Bus* starring a clever granny who trumps her snooty Neighbour by entering said bus in an art competition.

GRANNY NOTHING
Catherine MacPhail (Strident, 2012)

Granny Nothing is described as a 'rhinoceros in a frock' and she crashes into the lives of her grandchildren like a bull in a china shop.

SKARRS
Catherine Forde (Egmont 2008)

A touching novel of a boy who has fallen in with a neo-Nazi gang and is struggling to find a path out of his situation.

BOYRACERS
Alan Bissett (Polygon 2002)

Set in Falkirk, it describes a group of teenagers just teetering on the cusp of becoming adults.

Film, TV & Radio

Tilda Swinton, pictured here in Lynne Ramsay's *We Need to Talk About Kevin*, swings from arthouse to mainstream, from Scotland to Hollywood. She's not the only enterprising media professional making the best of both worlds ...

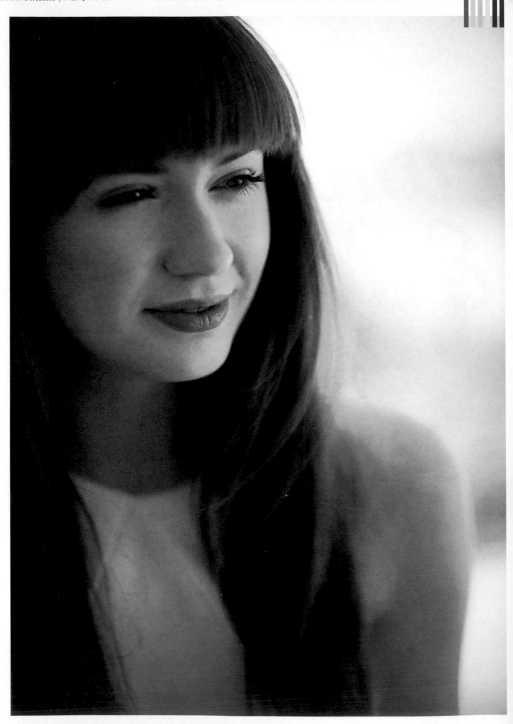

watch this space

After she played Amy Pond in Doctor Who, many wondered what Karen Gillan would do next. Eddie Harrison speaks to the Inverness actor about making the leap to the big screen with her first lead role in Glasgow-set film Not Another Happy Ending

Even if you've been hiding behind your couch for the last few years, (and viewers of *Doctor Who* are well known for doing exactly that), Karen Gillan needs little introduction. Playing Amy Pond opposite Matt Smith in the BBC's highest-rating drama, the Inverness girl has become a genuine household name. Now making the transition from television to feature films, she spent part of the summer of 2012 shooting *Not Another Happy Ending*, a romantic comedy developed by Scottish company Synchronicity Films.

'Actually, this film came about because my director John McKay, back when I was working on television for *We'll Take Manhattan,*' said, "You're really good at falling over, you should read this script," and gave me *Not Another*

Happy Ending. I suppose I am one of life's naturally clumsy people, I don't drop stuff all the time, or break things, but I'm just generally a bit flustered.'

In *Not Another Happy Ending*, Gillan plays Jane Lockhart, an author who has hit writer's block after the success of her first novel.

'The problem is she can only write when she's a bit miserable, and she's now a huge success,' says Gillan. 'So her publisher Tom [Stanley Weber] goes on this secret mission to make her life a misery, and it's all about how their relationship develops.'

Playing the role gave Gillan the chance to immerse herself in the rom-com genre, and enjoy a crash course in the most romantic comedies in cinema history.

➔

WELL-KENT FACES

It might not be immediately obvious but these Hollywood faces all have Scottish roots

KELLY MACDONALD

So good was her Texan accent in *No Country for Old Men* you'd be forgiven for thinking this Glaswegian was from the other side of the Atlantic. More recently Kelly Macdonald has worn her Scottish roots on her sleeve in Pixar animation *Brave*.

GERARD BUTLER

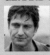

This lad from Paisley has become a Hollywood heart-throb thanks to his leading man roles in films like *PS I Love You, Law Abiding Citizen* and *300*.

TILDA SWINTON

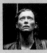

Living in Nairn, Swinton has made her name in both Hollywood and arthouse films, winning an Oscar for *Michael Clayton*.

BRIAN COX

From Dundee, Cox has built up a wide-spanning career from *The Bourne Supremacy* to indie gems like Wes Anderson's *Rushmore*.

EWAN MCGREGOR

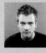

Perth-born McGregor has continued to land roles in Hollywood, long after his turn as Renton in Danny Boyle's adaptation of Irvine Welsh's *Trainspotting*. His next big film is *The Impossible*, about the 2004 tsunami.

← 'I watched in chronological order the greatest rom-coms of all time, starting with *His Girl Friday*, then *The Apartment*, which is amazing, and then I was naughty because I watched a later one because I couldn't wait to see *Manhattan*, then back to *Annie Hall* and then *When Harry Met Sally*... what I took from seeing them all was just how important the chemistry is between the two lead actors.'

With Howard Hawks, Billy Wilder, Woody Allen and Rob Reiner setting the bar high in terms of getting chemistry from their leads, Gillan's viewing left her plenty to ponder, not least how to create the right kind of connection with her leading man.

'How do you create chemistry? If only I knew that! Some people say it's a natural thing that you have with someone, and maybe it is to do with that, but I think you can work on it. We've been so lucky with Stanley Webber, because he's so spontaneous and inventive, so I have no idea what he's going to do next.

'I'm used to shooting at this momentum and pace from working on *Doctor Who*, so coming onto this film with the busy timeline we have feels quite natural. I was allowed to jump on the sofa if I wanted to, so I just did, because it just felt right in the moment. There's lots of improvisation in the film, we spoke about it with the director, and came to the conclusion that it was better when it was just

'How do you create chemistry? If I only knew that!'

free, and things could just pop out.'

Gillan's next project takes her to Los Angeles for a horror drama *Oculus*, but she's setting her sights even higher: she'd like to appear in darker, more dramatic films, and says her dream is to work with the Austrian director of *The White Ribbon* and *Hidden*, Michael Haneke, whose 2001 film *The Piano Teacher* is Gillan's own favourite film. But for now, she's keen to keep developing her craft, and *Not Another Happy Ending* gives her the chance to expand her repertoire with a coveted leading role.

'Acting is all about finding the truth within whatever world you're in,' she says. 'You just have to keep it truthful, rather than all this heightened acting. These are things that I've learned from watching the episodes of *Doctor Who*, just learning how to pitch a scene, so that you felt that you were doing enough to give the audience what they want at that moment.

'I watched all the episodes as they were airing. At first, when I saw myself, I really did cringe, but that's how you learn and get better. Now, I feel like I understand acting so much more, I've learned so much from working on *Doctor Who* and that's really coming into play on *Not Another Happy Ending*.'

Not Another Happy Ending is due for release in early 2013.

rising stars

A new generation is beginning to make its mark in the film world.
Gail Tolley picks out the names set for big things . . .

 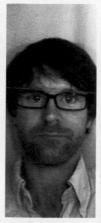

PAUL BRANNIGAN
ACTOR
(Glasgow, 1988)

Picked from obscurity by award-winning filmmaker Ken Loach, Brannigan made his acting debut in *The Angels' Share* and has subsequently starred in *Under the Skin* opposite Scarlett Johanssen.

ROSE LESLIE
ACTOR
(Aberdeen, 1987)

Having won a Scottish BAFTA award for her role in *New Town* (2009), Rose Leslie has gone on to impress audiences as Gwen Dawson in *Downton Abbey* and this year stars in *Now is Good* alongside Dakota Fanning.

JOHN MACLEAN
WRITER AND
DIRECTOR (Perth)

Maclean's short film *Pitch Black Heist*, starring Michael Fassbender and Liam Cunningham, won a BAFTA Award for Best Short Film in 2012. He was formerly a member of folktronica group The Beta Band and is now working on his first feature film.

GEORGIA KING,
ACTOR
(Edinburgh, 1986)

From teen drama *Wild Child* to black comedy *Burke & Hare*, Georgia King has become a popular face in British film in the last few years. Her next project is *Austenland*, the story of a woman obsessed with Jane Austen's Pride and Prejudice.

EMUN ELLIOT,
ACTOR
(Edinburgh, 1983)

You might recognise Emun Elliot from his roles in *Game of Thrones* and *Lip Service*. More recently he starred in *Prometheus* and returned to his home country to shoot the Irvine Welsh adaptation *Filth* (out next year).

Scotland on film

Gail Tolley chooses ten of the most memorable and iconic Scottish film locations

PENNAN, ABERDEENSHIRE
LOCAL HERO
(Bill Forsyth, 1983)

A young Peter Capaldi stars in this much-loved film about an American oil company looking to develop land surrounding a small Scottish village. The village scenes were shot in Pennan in Aberdeenshire where you can still visit the film's red phone box today.

ORKNEY

● INVERNESS

SKYE

LEWIS

EILEAN DONAN CASTLE
BRAVE
(Mark Andrew, 2012)

The world famous animators from Pixar were inspired by this distinctive castle, situated on Loch Duich, for their fantasy tale about a feisty Scottish princess.

ISLE OF SKYE
HIGHLANDER
(Russell Mulcachy, 1986)

This cult tale of immortal warriors used several Scottish locations including the rocky Cuillin Hills in Skye.

LOCHAILORT
BREAKING THE WAVES
(Lars von Trier, 1996)

The remote white church at Lochailort features in this powerful tale of a woman and her recently paralysed husband living in a deeply religious community on Scotland's west coast in the 1970s.

CAIRNGORMS NATIONAL PARK
THE DARK KNIGHT RISES
(Christopher Nolan, 2012)
The dramatic opening scene in Christopher Nolan's final Batman film was shot over the Cairngorms National Park. Showing a mid-air kidnap by villain Bane, it's a heart-stopping scene matched only by the stunning mountain backdrop.

EDINBURGH
SHALLOW GRAVE
(Danny Boyle, 1994)
Before his hit *Trainspotting*, Danny Boyle made another award-winning Scottish-set drama. *Shallow Grave* is about three Edinburgh professionals who find their new flatmate dead but in possession of a huge amount of cash.

GLASGOW
MY NAME IS JOE
(Ken Loach, 1998)
It's one of five films director Ken Loach has shot in Glasgow, but this one stands out for the impressive and heartfelt performance by Peter Mullan, a native Glaswegian, who plays the recovering alcoholic of the film's title.

DUNDEE

PERTH

EDINBURGH

STIRLING

GLASGOW

ARRAN

MULL

JURA

ISLAY

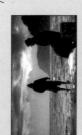

OBAN
MORVERN CALLAR
(Lynne Ramsay, 2002)
Samantha Morton stars as the eponymous Morvern who escapes her port town after assuming the authorship of a book written by her recently deceased boyfriend.

GLENCOE
UNDER THE SKIN
(Jonathan Glazer, 2012)
For this soon-to-be-released adaptation of Michel Faber's satire, about an alien traveller hunting hitchhikers, Scarlett Johansson spent several days shooting in the Highlands including at picturesque Glencoe.

ISLE OF MULL
I KNOW WHERE I'M GOING!
(Michael Powell and Emeric Pressburger, 1945)
Arguably Britain's most famous filmmaking duo, Powell and Pressburger took to the pretty Isle of Mull for their romantic hit about a headstrong woman on her way to marry a wealthy Scottish industrialist.

ruling the waves

Susan Mansfield celebrates the many talented actors, writers and producers working in BBC Scotland's radio drama department

Television drama might get the lion's share of the budget and the publicity, but there is a world of talent involved in making drama for radio – and no shortage of famous names either, with Brian Cox, David Tennant and Billy Connolly all willingly taking a turn in the radio studio.

The radio drama team at BBC Scotland punches well above its weight, making around 60 hours of programmes every year, most of which are aired nationally on Radio 4. 'It's a bit of a production juggernaut,' explains editor Bruce Young. 'Radio drama provides a huge amount of work for writers and actors in Scotland.'

The team mixes adaptations of classic and best-selling novels with original plays and serials, drawing on the talents of acclaimed writers. Donna Franceschild, best known for writing the television drama *Takin' Over the Asylum*, loves to write for radio and recently adapted John Steinbeck's classic of the American Depression, *The Grapes of Wrath*, for BBC Scotland. This follows her successful adaptation of Steinbeck's *Of Mice and Men* in 2010, which starred David Tennant.

Colin MacDonald, an Edinburgh-based writer for radio and television whose credits include *Sharpe's Honour* and the films *Calum's Road* and *Ivanhoe*, recently adapted *Dissolution*, the best-selling Tudor murder-mystery by CJ Sansom, featuring actor Jonathan Watkins (*Being Human, Lewis*) as hunchbacked lawyer Matthew Shardlake.

Chris Dolan, who is known as a playwright and novelist, is also a prolific writer for radio, most recently completing *The Strange Case of Dr Hyde*, a four-part contemporary thriller playing with elements of Stevenson's original story, to be broadcast in October starring David Rintoul. His other adaptations include Umberto Eco's *The Name of the Rose*, Gabriel Garcia Marquez's *Of Love and Other Demons*, and Janes Harris' *The Observations*.

Another talented multi-tasker is Ronald Frame, the author of some 15 novels, whose work for radio includes

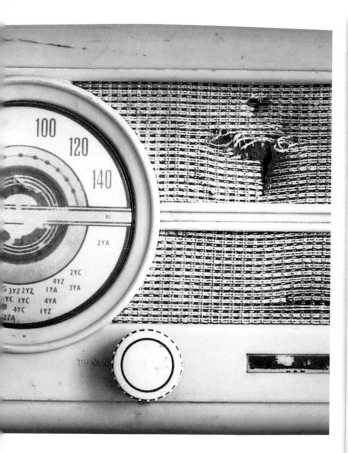

TAKE FIVE
SCOTLAND'S PODCASTS AND INTERNET RADIO

RADIO MAGNETIC
The UK's longest-running internet radio station, Radio Magnetic has grown from its original remit of playing underground dance music to presenting all manner of alternative music. *radiomagnetic.com*

JANEY GODLEY
Glaswegian comedian Janey Godley and her daughter Ashley chat about current goings-on in their regular podcast. *janeygodley.podomatic.com*

SCOTTISH POETRY LIBRARY
Weekly podcast featuring interviews with poets and those with a passion for poetry. Presented by the library's reader in residence Ryan Van Winkle. *scottishpoetrylibrary.org.uk/ connect/podcast*

THE ELLIE AND OLIVER SHOW
These two Glasgow-based artists present a weekly, themed radio show every Friday lunchtime from their flat in Glasgow's West End. A sideways look at contemporary living. *ellieandoliver.co.uk*

SONG, BY TOAD
A regular 'toadcast' from the popular Scottish music blog featuring a hand-selected playlist of indie tunes. *songbytoad.com/category/ podcast*

successful series such as *Carnbeg* and *The Hydro*, and his memoir *Ghost City*, which was later adapted for television. His most recent radio work is *The Other Simenon*, which adapts some of the lesser known fiction by the creator of Maigret.

Up-and-coming Glasgow-based playwright Oliver Emanuel is a prolific radio talent, winning a Bronze Sony Radio Academy Award for Best Drama in 2010 for his play *Daniel and Mary*. This season, he has written a stand-alone drama called *The Other One*, about a teenage girl who discovers she was swapped at birth with another couple's child.

David Ashton's Victorian detective McLevy, created for radio, was so successful that he has now spawned a series of novels. *McLevy* has now been running for ten years, and is about to record a ninth series starring Brian Cox and Siobhan Redmond.

Ashton went on to write *The Quest for Donal Q*, a contemporary adaptation of the story of Don Quixote, which starred Cox and Billy Connolly and was aired as a Christmas special in 2011. The publicity generated by the show provided a brief but important window into the achievements of radio drama which so often go unsung. Bruce Young says: 'The majority of people working in radio are fantastically well known in the business but are not household names, they're just incredibly successful talented people.'

A look at recent Scottish television drama reveals far more than police shows – whether it's lesbian life in Glasgow, the travails of comprehensive teachers or the pressures on a desperate dad . . .

Not so very long ago, Scottish television drama was dominated by *Rebus* and *Taggart*. The audience-conquering popularity of STV's Edinburgh and Glasgow cops was such that you could be forgiven for thinking Scotland hosted or produced little but crime dramas for the small screen. In more recent years, with the retirement of Inspector Rebus, and *Taggart* settled into the background as one of the UK's longest-running television shows, television drama made in Scotland has become more diversified, arguably providing viewers with a broader reflection of life north of the border.

Last year's *The Field of Blood*, a two-part thriller set in a Glasgow newsroom in the 1980s, adapted by Denise Mina from her own novel and starring Peter Capaldi, was the perfect example of quality home-grown drama. It was nominated for three BAFTA Scotland awards with Jayd

Johnson winning best television actress for her role as Paddy Meehan. Earlier this year, series two of *Lip Service*, the show about a group of lesbians living in Glasgow starring Laura Fraser, was screened on BBC Three. Fraser also appeared alongside David Tennant, who, post-*Dr Who*, returned home to make the four-part drama about a dad cracking up, *Single Father*. He was nominated for two acting awards for his performance. More recently, BBC One's series about teachers in a challenging comprehensive school environment, *Waterloo Road*, has relocated from Rochdale to Greenock. And more recently still, Douglas Henshall has been announced as Detective Jimmy Perez, star of the BBC One two-part crime drama, *Shetland*, to be filmed you know where.

OK, so Scottish television does give good cop. But it is also giving us a lot more than that. (Miles Fielder)

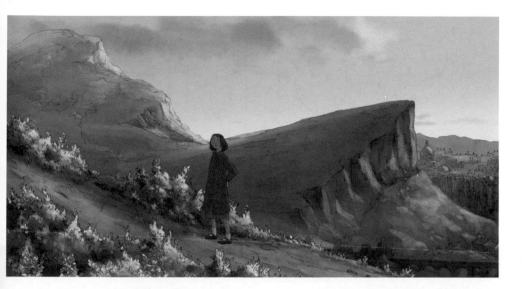

TAKE 5
scottish animation pioneers

When Pixar wants to tell a Scottish story, the world listens. But the global popularity of Princess Merida in *Brave* is only a small part of the story in terms of Scotland and animation. There's a growing confidence, skill and expertise in the industry, from computer games to feature films, short-form children's television and adverts.

INK DIGITAL

Bob Last and his company put Scotland on the global stage working with Sylvain Chomet for *The Illusionist*. Based on an idea by Jacques Tati, the Oscar-nominated film featured unforgettable animated views of old-world Edinburgh and the Scottish countryside.

KO-LIK FILMS

Partnering Ink Digital on projects, including forthcoming feature *Out of the Woods*, this Edinburgh company established itself as a household name with the one-off television specials *Haunted Hogmanay* and *Glendogie Bogey*. It also cracked the returnable television series with the *Ooglies*, the irreverent sight-gag show for children which is now on it's third season for the BBC.

AXIS ANIMATION

Whatever the final consensus about Ridley Scott's *Prometheus*, few would dispute that the original xenomorph design for the aliens was a classic. So it was quite a dream come true for this Glasgow studio when it was approached by Uber and Sega to work on animation for video game Aliens: Colonial Marines. Recent work also includes the eye-popping live action advert for *Street Fighter X Tekken*, plus animated prequels for *Zack Snyder's Sucker Punch*.

RED KITE

Established in 1997, this Edinburgh studio is in production with 26 episodes of children's magazine *Wendy*, about a teenage show-jumper. It is establishing quite a name for itself in the world of children's cartoons, notably through its work with Dennis and Gnasher, the popular characters based on the *Beano* comic.

SHOW THEM PICTURES

This specialist in using computer graphics and illustration to break new ground for animated projects won awards in 2010 for *The Lost Book*, an interactive web series written collaboratively with an online community. (Eddie Harrison)

scotland in the frame

Gail Tolley rounds up the local film production companies making an impact in cinemas across the UK and beyond

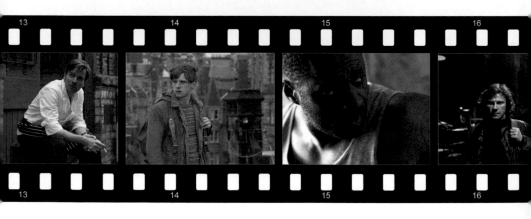

In the late 70s, when French director Bertrand Tavernier announced he wanted to shoot his next film in Glasgow, he was actively warned off the city by London producers who feared he and his cast and crew would be robbed – or worse.

Thankfully Tavernier ignored the scaremongers and went ahead and made *Death Watch*, the futuristic drama starring Harvey Keitel and Romy Schneider which recently enjoyed a re-release in UK cinemas. The film played a pivotal role in developing the Scottish film industry and today the country boasts a far more vibrant film and television making scene.

Surveying the crop of Scottish production companies, the first that jumps out is Sigma, established in 1997 by producer Gillian Berrie, director David Mackenzie and actor Alastair Mackenzie. It has been responsible for some of the biggest Scottish film releases of recent years including *Red Road, Young Adam* and *Perfect Sense*. Black Camel Productions is currently working on action horror *Outpost II* following the success of the first film and also the Idris Elba-starring, psychological thriller *Legacy*.

Autonomi on the other hand has become known for its documentaries, educational output and world cinema releases, such as the recent London Documentary Film Festival contender *Come Closer*. Also on the documentary front, Edinburgh's Scottish Documentary Institute produces many short films for television each year, giving emerging filmmakers the chance to get a foot on the industry ladder. And Matchlight in Glasgow has an impressive list of television accomplishments to its name, frequently working with the BBC, Channel 4 and 5.

And it might not technically be a production company but Park Circus deserves a special mention here for its sterling work in re-releasing restored classic films into cinemas across the world. Its recent projects have included David Lean's *Lawrence of Arabia* and Powell and Pressburger's *The Red Shoes* and the aforementioned cult Glasgow-set film *Death Watch*.

CONSOLE YOURSELF

Games & technology

Aidan Moffat worked with Edinburgh art collective FOUND on *#UNRAVEL*, a reactive sound installation that demonstrated the kind of imagination and energy at large in the world of technology. And there's more ...

ahead of the game

Since Rockstar North settled in Edinburgh in 1999, the Scottish video games industry has gone from strength to strength, but not without a little controversy along the way, as Cara Ellison finds

On Edinburgh's Leith Street a humdrum mix of cars, taxis and double decker buses circle a busy roundabout intersection. But inside that large glass building at Greenside Row, onscreen supercars race through red lights, hit tracks blaring from their radios – and everyone drives on the right. This studio is home to the one of the biggest game franchises in the world: Grand Theft Auto.

Its creator, Rockstar North, is the most important technology company in Scotland. The last title it developed, *Grand Theft Auto IV*, broke global game industry records and grossed more than $500 million in its first week of sales. By August of 2008, a mere four months after the critically acclaimed PS3 and Xbox 360 titles were released, the Top Global Markets Report stated it had sold 6.3 million copies in the US and UK alone. Its 2013 successor, *Grand Theft Auto V*, is set to open even bigger.

But not only is Rockstar North a major commercial powerhouse, led by producer Leslie Benzies with the creative direction of Dan and Sam Houser, the studio has changed the way that people think about games. GTA games explore the influence American popular culture has on us, taking the ultra-violence of 80s film and the soundtracks of a misspent youth and weaving them together in a colourful capitalist open world. What *Star Wars* did for science fiction films, *Grand Theft Auto* has done for games.

But the company is not only known for *Grand Theft Auto*. Not content with the media's outrage about the game's violence, the studio made *Manhunt* in 2003 to explore the willingness of its players to execute characters in various voyeuristic ways. Inspired by Stephen King's *The Running Man*, the pulp game was subject to heated debate in the mainstream media about whether it was a smart, philosophical approach to the human condition, or something more straightforwardly shocking, and was banned in several countries. Despite this, *Manhunt* was a success.

Rockstar North began life as a small studio in Dundee called DMA Design in 1987. DMA was acquired by Rockstar Games in September 1999, just before the release of *Grand Theft Auto 2*. DMA was renamed Rockstar North and relocated to Edinburgh, where it proceeded to make the groundbreaking *Grand Theft Auto III*, this time a fully 3D game. However, not all of DMA's talented staff moved to Rockstar North. Former employees of DMA have gone on to start numerous other games companies in Scotland, including Dave Jones' ill-fated Realtime Worlds. Still, from the ashes of that crisis the Scottish games development scene has burgeoned, giving us Ruffian Games, Denki, and many other mobile games developers.

Yet not everyone is aware of Scotland's status as a games technology powerhouse. A 2010 survey found that only 3% of UK young people knew that top-selling video games such as *Grand Theft Auto* were developed in the UK. With Dundee's Abertay University now leading the field educationally with its respected MSc in Computer Games Technology, there are many wishing to see it change.

TECH SUCCESS:
BLIPFOTO

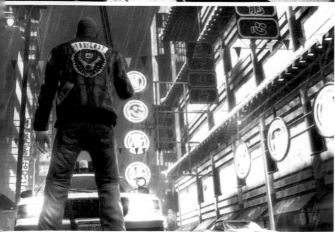

What started as Edinburgh photographer and designer Joe Tree's own daily photo blog has become - almost by accident - a global phenomenon, with users in over 160 countries who have uploaded two million pictures and counting.

Tree started Blipfoto as a personal project in 2006, assuming it wouldn't last - but before long had an online following clamouring for each day's pic, so the site expanded to allow user uploads. The rules are simple: users can post one photo per day, and the photo must have been taken on that day.

The beauty is in that simplicity: far from the sensory overload of other photography sites and online communities, Blipfoto's premise is straightforward and its design clean and ad-free. It's no surprise that everyone from Channel 4 to the National Theatre of Scotland has got involved: from a small base in Scotland, Tree has built up one of the world's most engaging and creative online communities. (Laura Ennor)

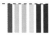

TAKE 10
technical innovators

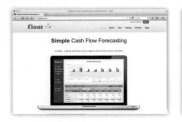

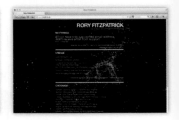

PHILIP ROBERTS

Philip is the founder CTO of Scottish cashflow forecasting start-up Float, viral blogger and hackday genius. An engineering degree and short stint at Wolfson led to a breakout into start-ups. Part of the team behind Shakey, a realtime Shakespearean parlour game built in 24 hours at Culture Hack Scotland in 2012.

@philip_roberts | blog.latentflip.com | floatapp.com

ALI KAJEH-HOSSEINNI

One half of the bro-founder super team at PlanForCloud, Ali is technical lead and cloud infrastructure builder extraordinaire. He set up PlanForCloud with his brother Hassan as a PhD candidate in cloud computing and within months they were snapped up by California-based RightScale to integrate with their cloud systems.

@AliKhajeh | planforcloud.com

RORY FITZPATRICK

Local boy Rory Fitzpatrick is becoming one of the most well known and liked people in the Scottish tech scene. A frequent hackday collaborator, Rory is extremely proficient in Javascript and focused on front-end interfaces and user experience. With strong opinions, understanding and a community focus, expect exciting things from him.

@roryf | roryf.co.uk

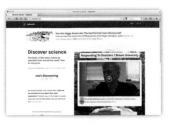

HASAN VELDSTRA

Hasan is one half of the power duo at VidioWiki, a website that helps scientists engage with the public through videos and workshops. They recently completed the extremely competitive springboard accelerator programme based at the Google Campus in London and are now back in Edinburgh to grow the company.

@hhv1 | vidiowiki.com

DALE HARVEY

Despite reaching the heights of programming prestige, veteran of the local start-up scene Dale Harvey has remained at the core of the developer community in Scotland. He recently joined Mozilla to work on their not-so-top-secret phone OS project Boot to Gecko with a team of international mavericks. He still finds time to run TechMeetup, the definitive monthly event for developers in Scotland.

@daleharvey | arandomurl.com

PHIL LEGETTER

Renaissance man Phil Leggetter works as the developer evangelist at Pusher, a real-time technology company doing incredible things connecting the web and mobile devices. In addition to being a skilled software engineer with a deep understanding of his subject area, Phil is an outstanding writer, communicator, thinker and maker.

@legetter | leggetter.co.uk

Devon Walshe is a publisher, entrepreneur, technical lead at cultural innovation programme Sync and deputy director of TechCube, a new Edinburgh-based incubation tower for tech businesses. He picks 10 leading local innovators

BILAL KHAN

The technical brains behind property management app AdvanceToGo, Bilal Khan and his colleagues are looking to disrupt the property management industry with their simple tool. Starting life as a spin-out from Edinburgh University with funding from LAUNCH. ed, AdvanceToGo recently launched with a cluster of funding.

@dvancetogo | advancetogo.com

JIM NEWBURY

Long time freelancer Jim Newberry moved to Scotland a few years ago and has been delighting programmer colleagues since with his playful sense of humour and approach to development. He recently joined the hotshot team at fantasy sports start-up Fanduel, which has closed big funding rounds and is taking a floor at TechCube.

@froots101 | tinnedfruit.com

JAMES BASTER

Classic coder James Baster is a fountain of ideas and free thinker on the open web, privacy and security issues. He was the principal organiser of Appleton Tower based TechMeetup between 2010 and early 2012 and has recently been working on government projects dealing with open data and public access.

@jarofgreen | jarofgreen.co.uk

ALI ESLAMI

Carnegie Scholar and PhD candidate Ali Eslami belongs to that exciting group working with machine learning at the University of Edinburgh's School of Informatics. Ali has shown creativity and flair with side projects including a site for students to trade used textbooks and anonymous messaging site digitalbottles.

@arkitus | arkitus.com | digitalbottles.com | bookadopter. com | keepmeout.com

TAKE 5
TECH EVENTS

CULTURE HACK SCOTLAND
A 24-hour hackathon first run in 2011, bringing together techies and cultural types to make something beautiful, useful or playful – or all three – from cultural data, from events listings to play scripts.
welcometosync.com

DARE PROTOPLAY
Gaming weekend built around Abertay University's prestigious Dare to be Digital games design competition, with play sessions and workshops for the public and stimulating discussion for the industry.
daretobedigital.com

TURING FESTIVAL
Technology festival named after the computing pioneer, aiming to capitalise on the density of creative talent in Edinburgh in August, with a particular focus on encouraging and facilitating start-ups.
turingfestival.com

EDINBURGH INTERACTIVE
Annual conference for the gaming industries with networking and a *Dragon's Den*-style pitch session, plus a public day with game previews and workshops.
edinburghinteractive.co.uk

NEON
Unique digital arts festival opening up links between the technology industries and creative arts by bringing the two worlds together in a spirit of collaboration and accessibility.
northeastofnorth.com

robot rock

Milo McLaughlin meets some of the musicians taking instrumentation into the digital age, right here in Scotland

Advances in technology have long played their part in pushing music forward as an art form, from Kraftwerk's devotion to drum machines and synths to Grandmaster Flash's canny knack with a crossfader.

And with technology now more accessible than ever, a growing number of Scottish-based musicians and artists are harnessing it in groundbreaking ways. Alternative songwriters such as The Pictish Trail, Jonnie Common, and Conquering Animal Sound all combine devices such as samplers and loop/effect pedals with more traditional instrumentation, creating something new and unexpected.

Taking things in an even more experimental direction are the likes of FOUND and Yann Seznec, both of whom showcased their work at Scotland's first ever Music Hack Day in August 2012, organised by the Leith Agency and Scottish Music Industry Association.

'We've almost got to a point with technology that if you can imagine how it would work there is a way of doing it,' says Simon Kirby, Professor of Language Evolution at the University of Edinburgh. Kirby is also one quarter of the band/art collective FOUND, along with Ziggy Campbell, Tommy Perman and Kev Sim (who also creates electronic music under the moniker River of Slime).

FOUND, who are signed to Glasgow-based label Chemikal Underground, have received international acclaim for their installation-based sound and music projects including the BAFTA winning 'emotional robot band' Cybraphon and their mind-bending collaboration with Aidan Moffat, #UNRAVEL. Their latest project is a smartphone app designed to be a souvenir for the 2014 Glasgow Commonwealth Games. The app's soundtrack constantly changes depending on how close the listener is to the city and in which direction they are facing.

According to Campbell, no matter how useful technology is when it comes to the creative process,

the ideas always have to come first. 'With #UNRAVEL we were like, let's come up with a really ballsy, ambitious idea. We've no idea how we'll do it or if it'll work, but if we just sit and come up with the idea and give ourselves enough time I'm sure we can figure it out.'

That said, technology itself does influence the final result in unexpected ways, as Perman points out. 'For Cybraphon and #UNRAVEL we built the mechanical musical instruments before we could write anything for them, so we had to learn how to compose for them. That made us write music that we wouldn't have written otherwise, which is what made it interesting.'

Yann Seznec records music under the name of The Amazing Rolo and is founder of Lucky Frame, a small Edinburgh-based company which produces music-based smartphone apps and other quirky creations. He developed a unique instrument for Matthew Herbert's One Pig project, dubbed The Sty Harp, by hacking discarded gametrak controllers ('an obscure, failed motion controller'). As a result he is now a part of Herbert's live band, and has performed in a number of exotic locations round the world.

'Certainly in the past few years it has become much easier to access and use technology in a creative fashion', says Seznec. But despite the rewards, it's still not a simple process. 'It still is quite frustrating and time consuming in many ways, and sometimes I need to just sit down and play some piano or build the simplest thing, just to clear my head.'

Indeed, both FOUND and Seznec emphasise that when faced with almost limitless possibilities, focus is essential. 'If technology isn't providing any limit, then you need to take your limit from somewhere else', says Kirby. Seznec agrees: 'The best thing to do is to design a really focused project for yourself, then work out what tools and knowledge you need in order to do it, and then do it. Stay focused on your creative goals, rather than getting lost in the world of software or hardware possibilities.'

It's not just the painters, musicians and poets who make Scotland's creative industries tick
– there are thousands of people working hard behind the scenes to make creative projects

GWILYM GIBBONS
DIRECTOR, SHETLAND ARTS DEVELOPMENT AGENCY

Our location in Shetland requires us to look out to sea and so prompts a range of relationships that reach far beyond our shores. In many ways we act and behave like a national company working across borders and with people of international renown. At the moment I'm inspired by ideas that capture the value of our creative output. I have been working with others developing new ways of realising the value of our intellectual property enabling us to invest in creative ideas that otherwise we wouldn't have the resources to support. The most exciting aspect of my work is the magic, surprise and joy that comes from those moments in which a creative event touches and connects with an individual. It's hard to describe but it sends a real tingle along the back of my neck.

ROBYN MARSACK
DIRECTOR, SCOTTISH POETRY LIBRARY

When I introduce myself people invariably say, 'That must be a lovely job!' and then, 'Are you a poet?' It is a lovely job, and I'm neither poet nor librarian. My role is to hold together the extraordinary energy, creativity and knowledge of the SPL team, and make sure that all our work achieves our aim of bringing people and poems together: through the collection; in schools and care homes; in events and via the website; through social and broadcast media – taking Scotland's poetry out and about, and bringing the world's poetry in. We're unique in Scotland and a rare library in world terms, a hub for poetry with a lending collection as our base. I'm inspired by the dedication of my colleagues; by the generosity of the anonymous book sculpture artist, whose work we're touring; and by the art of poetry, first and last.

and events happen, and their jobs give them unique access to what's up-and-coming in the arts. We caught up with a few and asked them, 'what's the most exciting part of your job?'

HAMISH PIRIE
ASSOCIATE DIRECTOR, TRAVERSE THEATRE

The best thing about my job is working with writers at the early stages of an idea. It's a thrill and honour to be there at the beginning and then follow the process through. I get to live in anticipation of every envelope I open as it could be the one to blow me away. It is a privilege to be sent scripts when you think about how much emotional and actual energy goes into their creation.

There is so much talent in Scotland, especially at the writing end. I am inspired by so many, but writers such as Rob Drummond, Kieran Hurley and Gary McNair are constantly redefining what a writer is. Lynda Radley, who wrote one of our *Dream Plays* during the Edinburgh Fringe, has a wickedly urgent voice.

SUZY GLASS
CO-FOUNDER, TRIGGER

I'm a producer, which means I work with ideas, makers and audiences, joining the dots between the three. I do this job because I'm interested in finding more creative ways of communicating. Producing is a multi-faceted, complex job, but for me the element that sits at its core is the bringing together of brilliant people to develop ways of talking expansively about being human. On a daily basis I work with artists, designers, technologists, thinkers and scientists. It's this meeting of minds that I find exciting, so I develop and facilitate collaborative processes that give people the space to turn good ideas into great ideas. I work in the arts because I believe creativity can help us to find ways of existing in a more balanced, meaningful fashion.

HEATHER COLLINS
CHILDREN'S AND LEARNING AUDIENCE DEVELOPMENT CO-ORDINATOR, SCOTTISH BOOK TRUST

There are many exciting aspects to my job but the thing that I enjoy the most is meeting teachers who tell me that taking part in our author events or projects like the Scottish Children's Book Awards has really had a positive impact on their pupils' reading habits. I've been able to meet some of my childhood heroes like Michael Rosen and David Almond which is amazing – I always make sure I get my books signed too! I love chatting to all the enthusiastic children in the signing queues and seeing their delight at meeting a real live author. The job is never dull, I've dressed up as a clown, and grown into a nut tree for Julia Donaldson. Last week I was making George's Marvellous Medicine. I feel very lucky to have a job I believe in but that's also so much fun.

DR FIONA BRADLEY
DIRECTOR, FRUITMARKET GALLERY

What I love best about my job is working with artists to make commissions, exhibitions and books. Shows at the Fruitmarket Gallery are free, so artists can take risks – we try to help audiences understand and enjoy all the art, but if they like one exhibition less than they expected, they don't need to feel cheated. We sit between the might of the National Galleries and the energy of artist-run spaces like Rhubaba. We show art in a resolutely international context: Scottish art and audiences are world class and we celebrate that throughout the programme. I'm inspired by great art, whether that's Martin Creed's generously beautiful work on the Scotsman Steps here in Edinburgh, or two films I saw at Documenta last summer: Willie Doherty's *Secretion* and Omer Fast's *Continuity*, both of which keep coming back to haunt me.

CHRISTOPHER AIRD
HEAD OF DRAMA, BBC SCOTLAND

The most exciting aspect of my job is having the chance to work with the best writing, directing and acting talent to produce original drama here in Scotland. We have some really exciting projects in the pipeline. We want the BBC Scotland drama department to be the first port of call for all Scottish dramatists interested in writing for the screen. We are working with the theatre community to tap into the hugely successful Scottish playwriting scene and will be launching an exciting writing initiative later in the autumn. It will sound corny, but I am captivated by the soulfulness of Scotland; there is a depth of feeling up here that is unique – a gift for any dramatist. I am also stunned by the beauty of the place. I saw Stirling Castle for the first time last weekend – who knew?

JOHN WALLACE
PRINCIPAL, ROYAL CONSERVATOIRE OF SCOTLAND

The most exciting part of my job is finding young talents and seeing them realise and develop their own potential. At the moment I'm inspired by James MacMillan, Nicola Benedetti, Andy Murray, Chris Hoy, Vicky Featherstone, Maggie Kinloch and all the people who work at the RCS including Norrie Woof, the maintenance guy – we're living in a golden age of performing artistry and a culture of inventiveness in Scotland and we don't really comprehend fully its power. I help manufacture the fertiliser so that there can be an arts industry in Scotland. I help to solidify the weight of opinion that justifies the arts' right for existence in competition with other life-and-death demands on the public purse, and I try to ensure that the supply of young talent has relevant skills for the rapidly changing arts scenario. What I do is invisible and terminally boring.

ELAINE COYLE
HEAD OF WARDROBE, CITIZENS THEATRE

I've been at the Citizens eight years. I was a freelance costume designer and initially became a cutter in the Citizens wardrobe department, then in 2008 became full-time head of wardrobe. I am in charge of a team of cutters/sewers and dressers. For each production we either source or create costumes from scratch in line with the show designer's drawings. It is amazing to see the whole process from start to finish – what begins as a drawing on a piece of paper actually becoming real onstage live as part of a production. Being in the Citizens building is exciting as well. The atmosphere is brilliant and everyone is so passionate about what they are doing that there is a real buzz about the place. Costumes are such an important part of the theatre experience, helping to bring stories to life for audiences across the country. The wardrobe department at the Citizens plays its part in making the theatre one of the UK's most iconic venues.

OWEN CALDWELL
GENERAL MANAGER, OLD BRIDGE INN, AVIEMORE

We have so much dialogue here with artists and managers, that each day there's a lot of to-ing and fro-ing as we search for the right acts, on the right dates, for the right price. Not an easy feat, given our location in the middle of the Highlands and the level of diversity we aim for. We don't have a large population to pitch to, so ensuring we don't over-programme our gig schedule is key. When you've been working hard to nail down a date with someone and it's then confirmed, it really does put a spring in your step. On the night, it is so pleasing to see people's reaction to the acts we bring to Aviemore. Tartan and shortbread guitar cases, most certainly, checked at the door. In terms of inspiration, we look to our great friends at Backwoods Productions, who put on the Insider festival up here every year. They have been setting the standard when it comes to contemporary music in the Highlands for the last four years, which we strive to complement.

LINDSAY ROBERTSON
MANAGER, SCOTTISH NATIONAL JAZZ ORCHESTRA & TOMMY SMITH'S YOUTH JAZZ ORCHESTRA

There is nothing so exciting as the buzz of a live concert – being on tour, seeing how passionate the musicians are about their music and the pleasure it brings to audiences. I changed careers from nursing to music and jazz and love both – they are inspirational and fulfilling, sociable yet autonomous and with attention to detail and good communication paramount – plus with the ability to react calmly and quickly an essential skill. As SNJO manager, my role encompasses admin, artist liaison, PR, marketing, fundraising and networking, which frees the artistic director, Tommy Smith, to concentrate on the music. It is very satisfying to know your role has contributed to the organisation and success of concerts – the wonderful music, musicians and special guests are all inspirational. To then experience the live performances and applause of audiences – wow! – it is as good as being on stage myself.

FAITH LIDDELL
DIRECTOR, FESTIVALS EDINBURGH

I'm the director of Festivals Edinburgh, the strategic umbrella organisation for our city's 12 major festivals. The festival directors created and own our organisation, and my job is to work with them to ensure that Edinburgh maintains its position as the world's leading festival city and to develop and deliver their collective projects. A lot of my time is bringing in investment and partnership to support our joint ambitions. We're also looking ahead, future-gazing and developing models that other cities and organisations want to learn from – not just within Scotland, but globally. I feel endlessly inspired by the vision and drive of my directors and the Scottish and international artists and thinkers they work with. I get to keep company with astonishingly committed and creative people.

JAMES GRAHAM
DEVELOPMENT MANAGER, AN COMUNN GÀIDHEALACH

An Comunn Gàidhealach is a Gaelic language organisation. We organise Am Mòd Nàiseanta Rìoghail (the Royal National Mod), Scotland's largest festival of Gaelic language and arts. We aspire to promote and raise the profile of the Gaelic language, especially among the younger generation and learners of the language. I am extremely passionate about the language and I'm in the fortunate position where I get to use the language day-to-day as part of my everyday work. I am also a musician and therefore the nature of my work has added appeal.

PETE IRVINE
MANAGING DIRECTOR, UNIQUE EVENTS AND ARTISTIC DIRECTOR, EDINBURGH'S HOGMANAY

I run Unique Events, which is the major open-air events company in Scotland, and I'm also the author of Scotland the Best. They're both about discovering, rediscovering and celebrating Scotland. The interesting thing that I feel I do is making things happen that don't exist already, and bringing people, or things that they create – an artwork, an event, a restaurant – to wider attention. What I do evolved from my interests and working with people around me. I think I helped to create the landscape of the festival and event world that I inhabit, and I'm still travelling in it. It's a good time to be in Scotland.

Index

See also the online directory of organisations at list.co.uk/wecreate